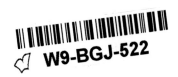

THE END OF POLIO

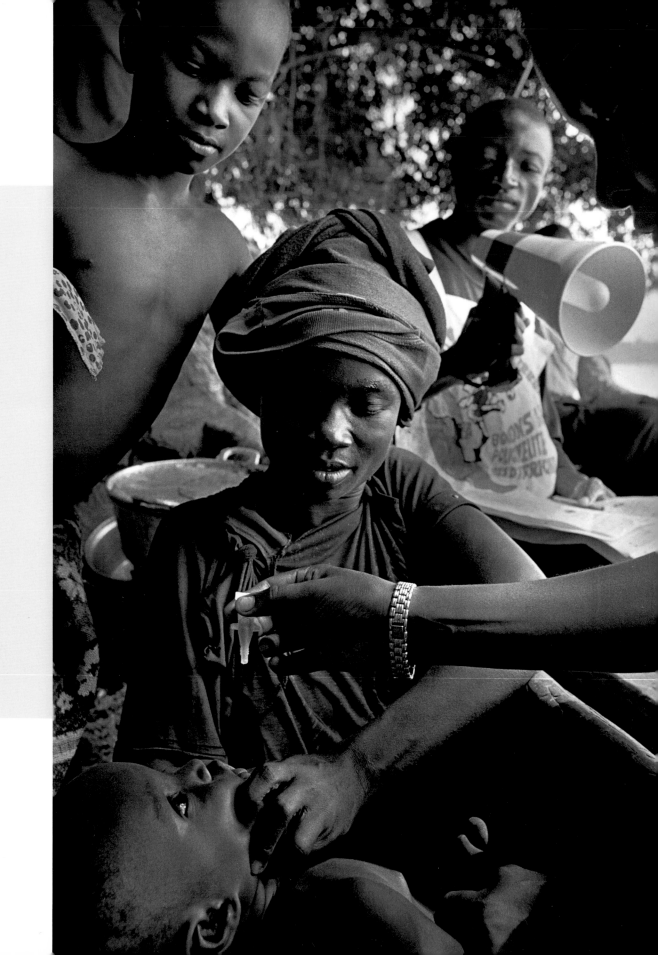

Foreword by Kofi A. Annan

THE END OF POLIO

A Global Effort to End a Disease

Photographs by
Sebastião Salgado

Bulfinch Press
AOL Time Warner Book Group
Boston • New York • London

THIS BOOK IS DEDICATED TO
ALL THOSE WHO COURAGEOUSLY LIVE WITH POLIO,
AS WELL AS TO ALL THE HEALTH WORKERS
WHO SO LOVINGLY HELP THEM
WHILE WORKING TO ELIMINATE THE DISEASE.

(Right) INDIA, 2001. Children at the Amar Jyoti Rehabilitation and Research Center, which was founded in 1981 in Karkar Dooma, New Delhi, to care for polio-disabled children. The center provides integrated education, occupational therapy, physiotherapy, vocational training, textile design and carpentry classes, and many other services. (Title page) DEMOCRATIC REPUBLIC OF CONGO, 2001. A child receives the oral polio vaccine during a vaccination campaign in the Kisangani region, near the Congo River.

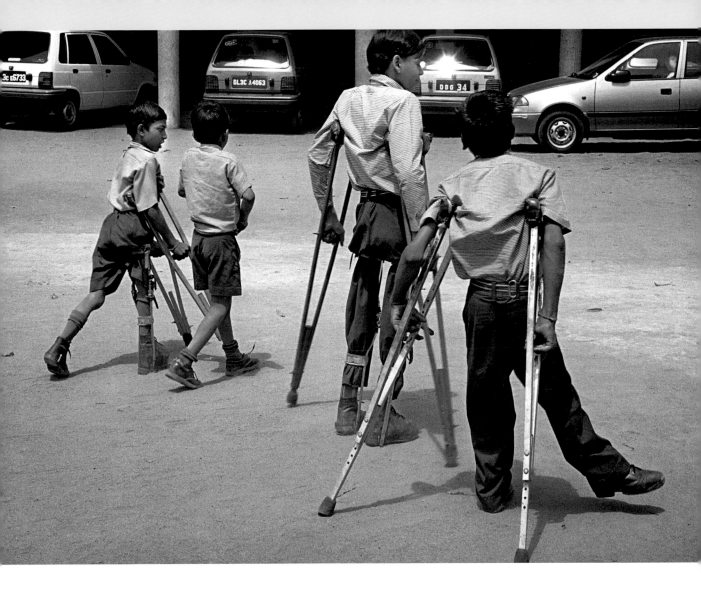

Contents

FOREWORD

by Kofi A. Annan,
Secretary-General of the United Nations

Winsome girls in wheelchairs. A boy, his legs paralyzed, hurrying to a football match on his hands and knees. A girl on crutches, struggling to get off a school bus. As Sebastião Salgado's luminous photographs attest, there are few more heartbreaking illustrations of the world's negligence towards children than polio.

That the virus still exists at all is itself an indictment, for this is a disease that is completely preventable. Protecting a child from polio is as easy as shielding that child from the rain: it means opening the medical equivalent of an umbrella—in this case, an easily administered vaccine developed nearly a half-century ago. Nor is there any mystery about how to do away with polio forever. All it requires is ensuring that all children up to 5 years old receive the recommended doses of oral polio vaccine every year—and that all cases of paralysis are investigated fully until we can certify that there is no more polio.

The real heroes of this campaign against polio are the health workers—most of them unpaid volunteers—who combine ingenuity with courage and grit to deliver the perishable polio vaccine and see that it is properly administered. Their work is fraught with dangers, ranging from snakebites to gunfire. In some conflict zones, warring factions have been persuaded to put down their weapons long enough to allow children to be immunized. But even where there have been no "days of tranquillity," as these mercy truces are called, polio-eradication workers have gone about their appointed rounds anyway—and some have been killed in the process.

Their sacrifice has not been in vain. By 2002, there were only 200 new cases of polio-induced paralysis in all of Africa. And with the worrying exceptions of India, Nigeria and Egypt, the number of worldwide cases of polio has continued to decline, while the countries classified as polio-endemic have dropped to seven, the fewest ever.

This is an achievement of historic proportions. Yet the eradication of polio by the internationally agreed upon target date of 2005 is by no means assured. It depends on securing the resources still needed to carry out immunization; on the readiness of all parties in armed conflict to ensure safe access to children at risk; and on the effectiveness of the continuing effort to educate families about the importance of immunization.

Until we reach our goal, the United Nations will continue to play its full part in the struggle against this disease. *The End of Polio* is a beautiful tribute to that struggle, and to the millions of dedicated people who, I am confident, will help us get there, thus making the world a better, safer place for every child.

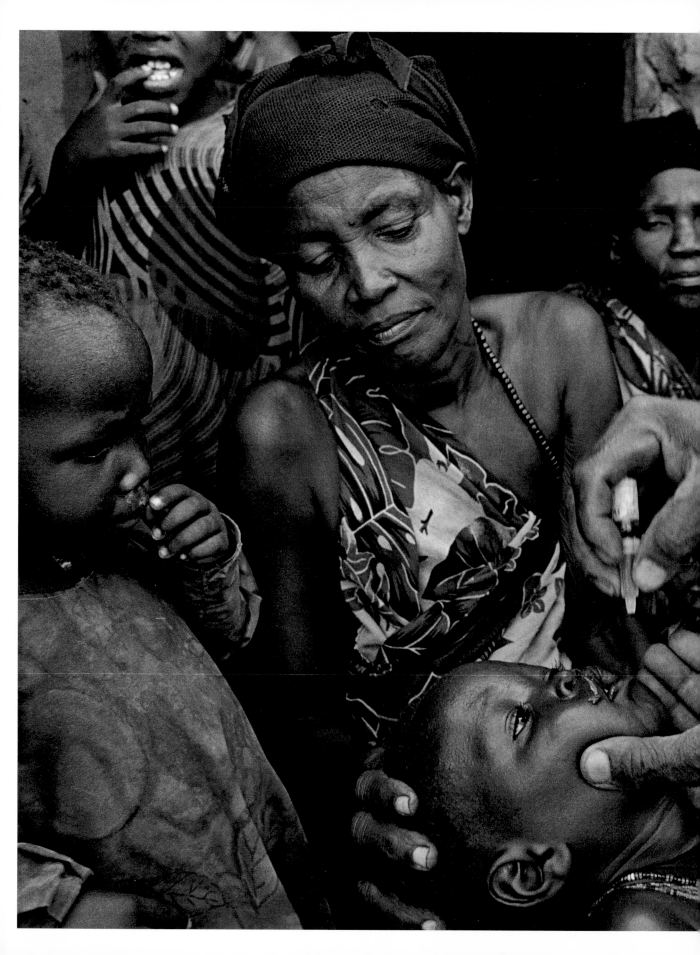

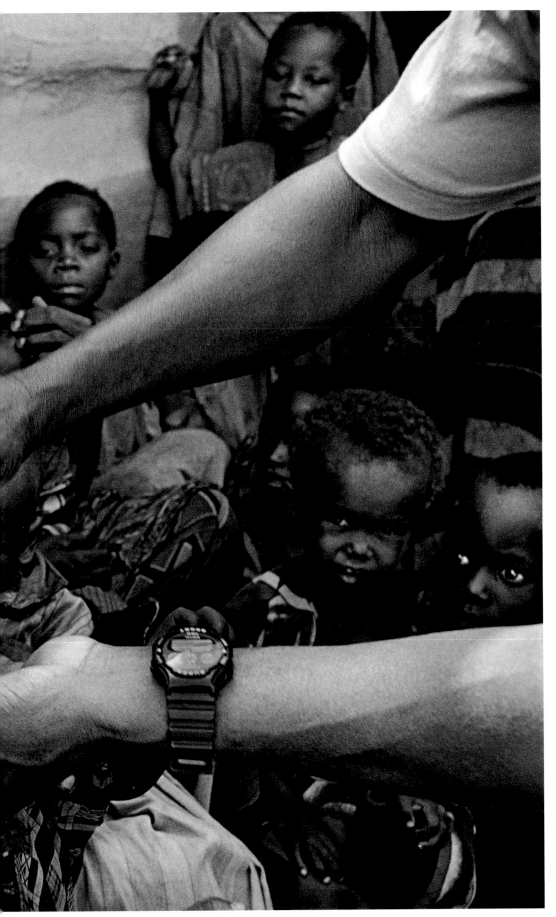

SOMALIA, 2001
In Sabbatum, villagers gather for a round of polio immunizations. For some villagers, the vaccinators are the first health workers they have ever encountered.

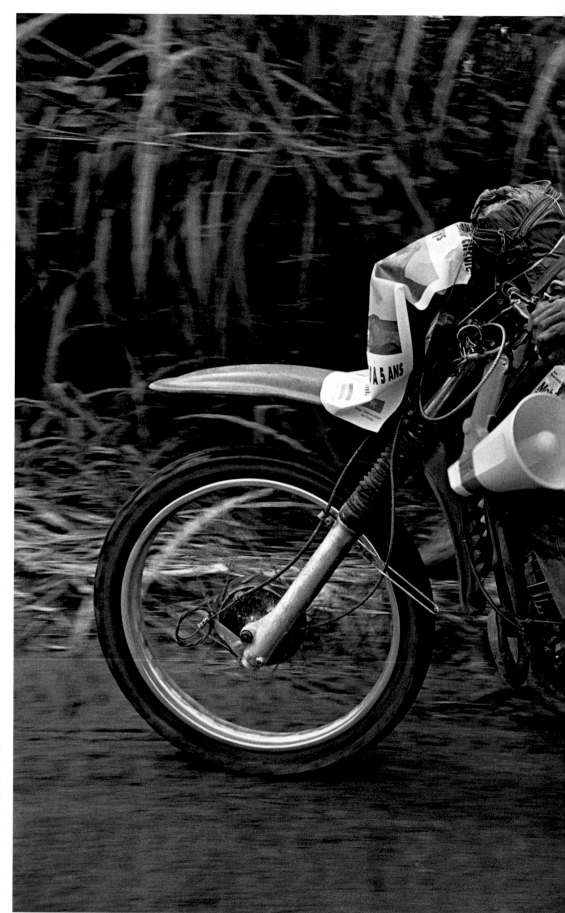

DEMOCRATIC REPUBLIC OF CONGO, 2001
A team transports chilled containers of polio vaccine down the "cold chain" from Kisangani to villages in the equatorial forest. This motorcycle carries the fuel needed for the whole group of vehicles.

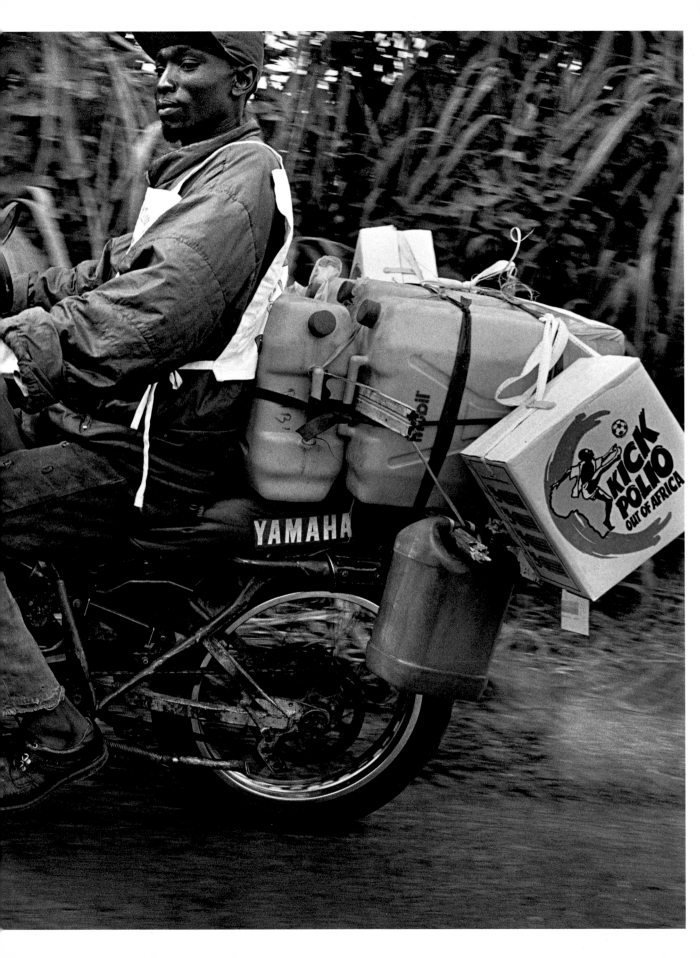

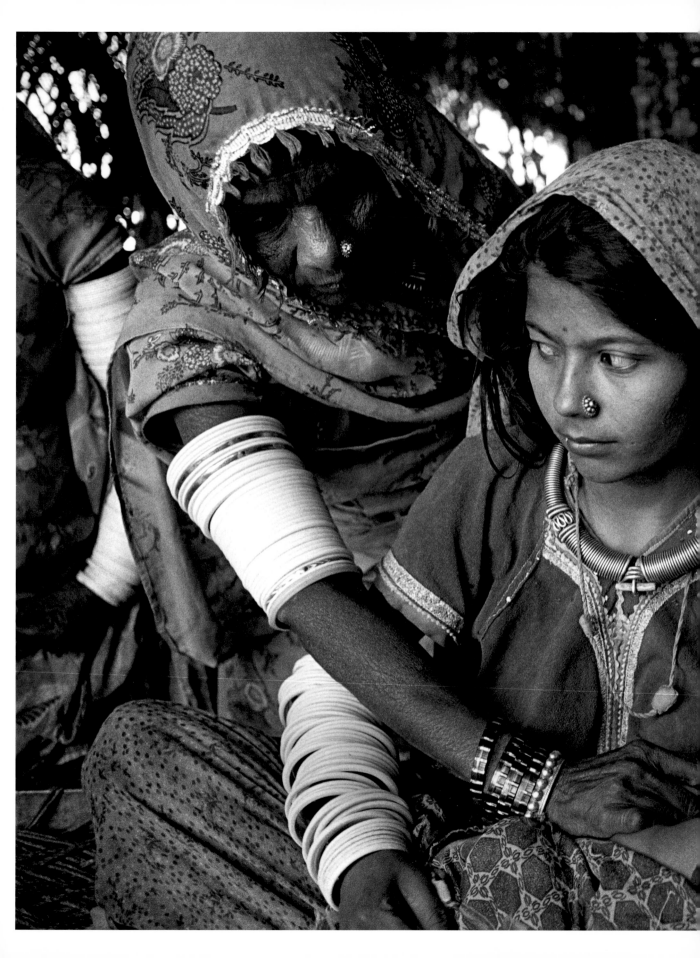

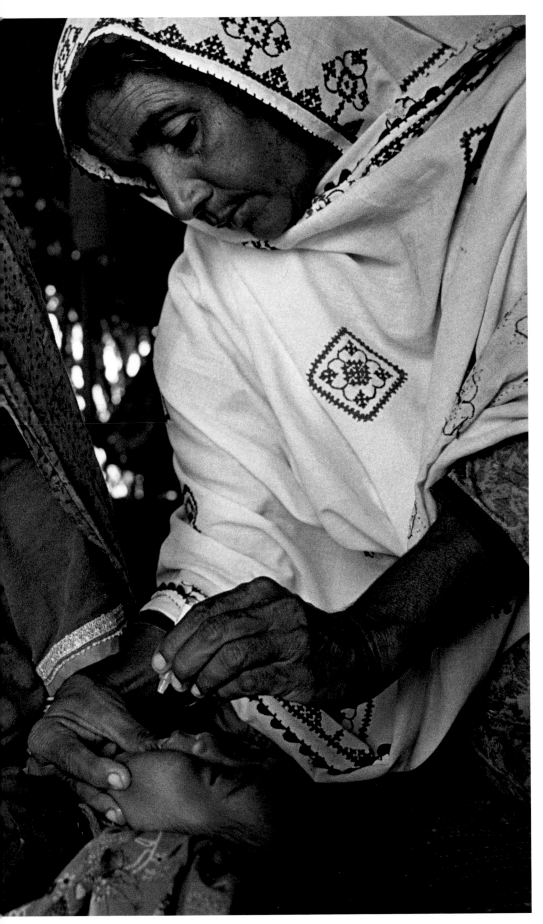

PAKISTAN, 2001
The polio vaccine is administered in the village of Irro-Jo Whandhio in Mithi District, in the Thar Desert near the border with India's Rajasthan State.

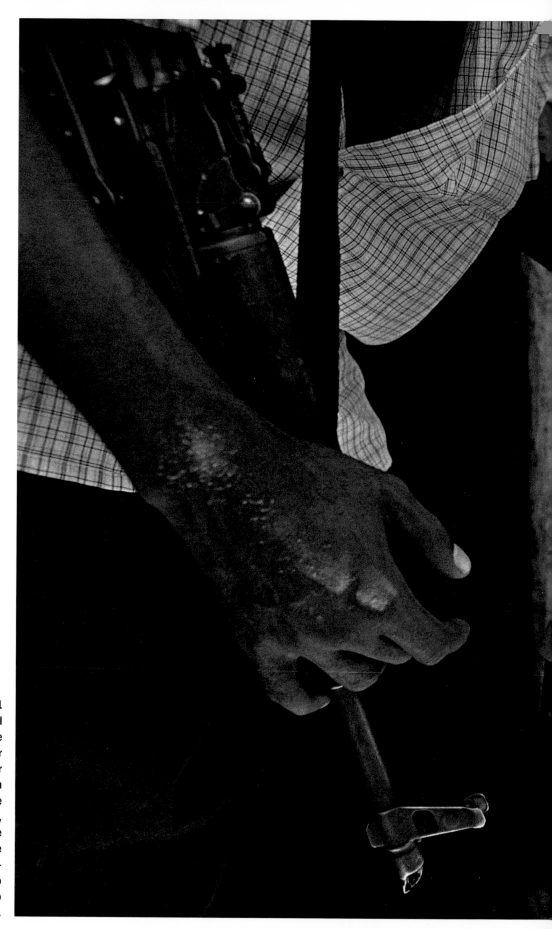

SOMALIA, 2001
In 2001, several polio workers were held captive after a battle between their guards and militia from another clan. Because of continuing conflict, armed guards like these, in the village of Aboorrow, accompany foreigners who participate in polio eradication campaigns.

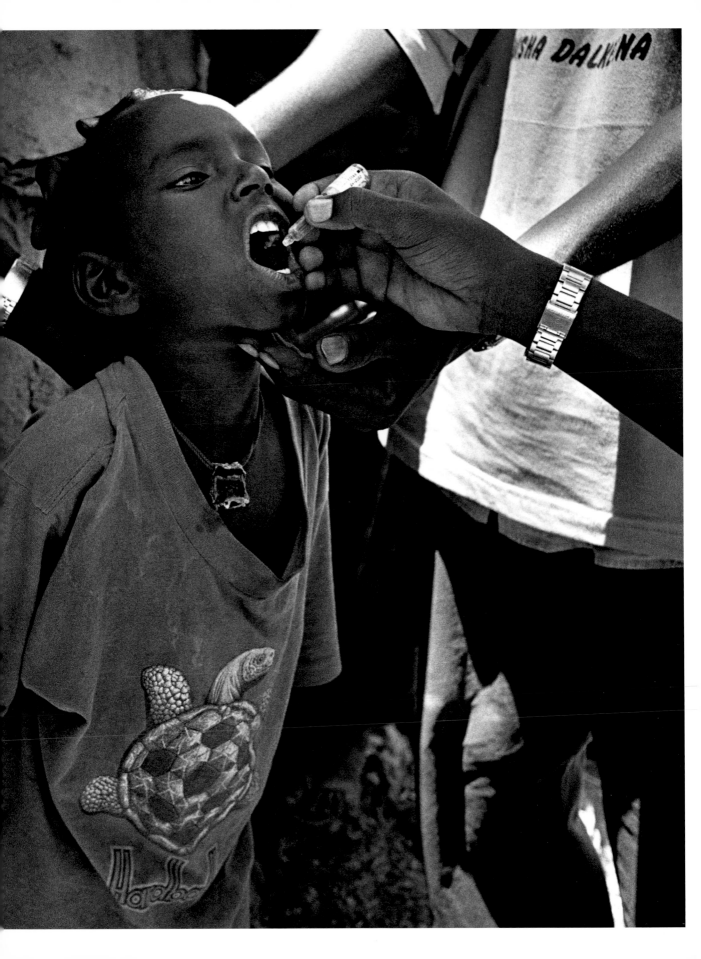

INDIA, 2001
A girl from the Amar
Jyoti Rehabilitation
and Research Center
in New Delhi gets
off the school bus.

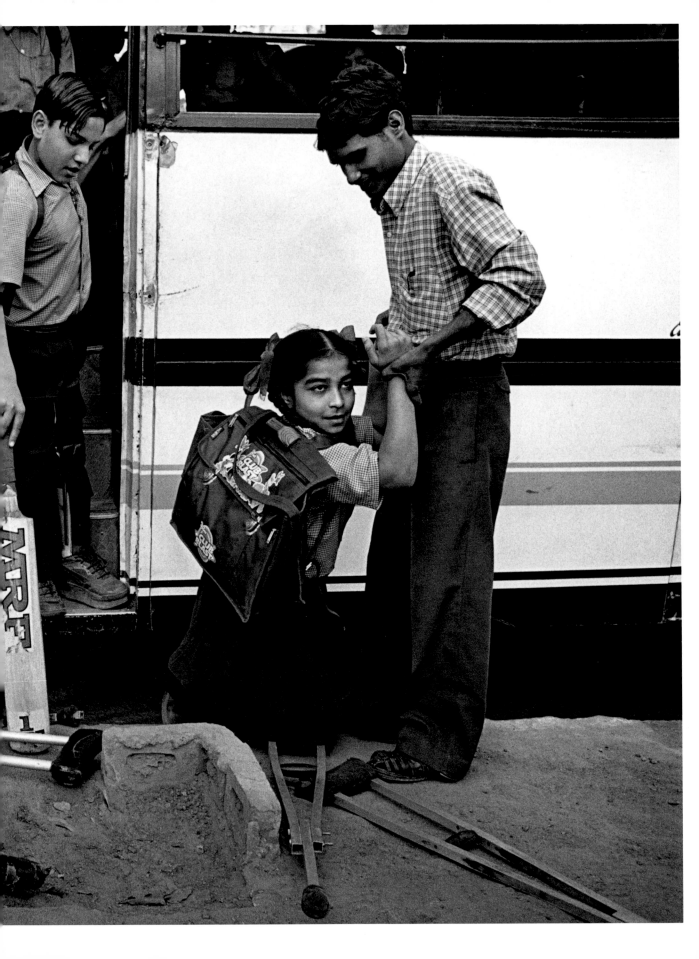

A GLOBAL EFFORT TO END A DISEASE

by Siddharth Dube

PRATAP, MY BROTHER

On the morning of September thirteenth, 1961, Pratap, my eldest brother, then only four, was suddenly paralyzed from his throat down by polio. Within hours, the virus had robbed all muscle and fat and strength from his little-boy legs and was invading his spine, threatening to immobilize his lungs, attempting to suffocate and kill him.

That night, at the very hospital where Pratap had been admitted to intensive care only hours earlier, our mother, Savitri, in her terrible anguish, gave birth to me prematurely. I was born while Pratap teetered on the brink of death just two floors below, his piteously tiny frame riddled with tubes, dwarfed by the cold bulk of life-support machinery, heartbreakingly alone, our parents barred from going to him.

For an agonizing week, our mother and father did not know whether Pratap would survive. He lay connected to the life-support system in Calcutta's Woodlands Hospital for three days, then, still not out of danger, remained in intensive care for another four days. Throughout this week, Basant, our father, stood outside that unit, praying that Pratap would be spared, that the poliovirus would take him instead.

Pratap, my beloved and brave brother, lived. After spending several weeks isolated in the contagious diseases ward, he left the hospital in early October. But his nightmare from polio was far from over. Because of the severity of the damage inflicted on him, ahead lay a series of harrowing operations that tore apart his legs, a regimen of physiotherapy that often left him weeping with agony, and, to this day, chronic and often excruciating pain.

The paralysis had decimated both of Pratap's legs. Mercifully, his spine and upper torso escaped permanent damage. With massage and physiotherapy, the strength returned to these parts of his body over the next few weeks. Still, much of the damage inflicted on him by polio is permanent.

As soon as possible after his paralysis, our parents took Pratap to India's leading orthopedic hospital in Mumbai where he gamely submitted to months of arduous physiotherapy. Our father recalls that first visit: "To take him to the hospital and see countless

children, maybe a thousand children, paralyzed by this dreadful virus, was like walking into a living hell."

Three months of agonizing physiotherapy, aimed at slowly stretching damaged muscles grown over with rigid, inelastic, fibrous tissue, helped Pratap to recover as much strength in his legs as was possible. Unfortunately, this was not much at all, particularly in his right leg.

Eventually, he was fitted with a removable steel caliper (a full-leg brace) held to his right leg with leather straps. Slowly, slowly, Pratap learned to walk again, dependent on his stronger left leg, dragging his right leg—stiffly encased in the heavy caliper—behind.

Our father remembers: "Often when Pratap would ask, 'Papa, when do you think I can run again?' I could only murmur 'soon.' Yet he was always smiling, cheerful and endeavoring to get back on his feet. I have always been in awe of his courage."

In mid-1963, at age six, Pratap had his first operation, again at the Mumbai hospital. The surgery involved cutting the shrunken, contracted muscles in his hip, a procedure that was supposed to result in freer movement of his legs. Once again, he was confined to a bed for weeks of recovery. Once again, he submitted to several more weeks of freshly agonizing physiotherapy, learning again to balance, relearning how to walk.

Less than a year later, our parents took Pratap to London to be treated by orthopedic specialists in Harley Street. The hip operation had not been successful after all, so the British doctors redid it. Again, weeks of suffering, followed by weeks of physiotherapy.

In 1976, at the age of nineteen, Pratap returned to London to undergo two more operations—the most excruciating yet—in order to stabilize his right ankle and straighten his left leg. After these two procedures, he was forced to spend six horrific months with both legs encased in plaster, unable to move without assistance. There followed six more months of arduous physiotherapy. Pratap had to overcome the surgical wounds and to relearn, yet again, to balance and to walk.

Still another brutally invasive operation—to straighten his right knee—was planned for the next year. In the end, though, Pratap and our parents refused to go through with it. He had already suffered far too much.

Despite all this—the operations, the chronic intense pain, the physical challenges—Pratap has carved out a bold, admirable, and wonderful life. In his early twenties, he was one of India's finest amateur golfers. By his early thirties, he was a very successful businessman. He has a joyous family, including a young son with whom he plays cricket. In the maelstrom of brashness and violence that is modern-day Delhi, Pratap is unflappable, fearless, assured, wildly humorous, and always kind.

Unlike Pratap, the scars I bear from polio are entirely emotional. But they are deep—the result of feeling guilty for being born on the day that Pratap was paralyzed, of

having taken care of him when we were children, of loving him and having to watch him suffer. I am haunted by polio, by disability, by suffering. Consequently, at the age of thirty, I gave up working as a journalist and went into public health, hoping that somehow I could help save some people from the kind of terrible suffering I have witnessed Pratap endure. As with many of the important decisions I have made in life, Pratap was the inspiration for this choice.

A WORLDWIDE AFFLICTION

In India, my homeland, physical suffering is commonplace, a harsh fact of life. Yet, no cause of physical suffering in India matches in sheer wretchedness the suffering caused by severe, permanent disability. Much of this disability, until barely half-a-decade ago, was caused by polio. If you have ever seen them, can you forget those beggars, in every city and town, with their impossibly withered, polio-mangled limbs, unable to stand, dragging their torsos along the ground, or on those crude boards with wheels? Can you ever forget those sports events for the disabled, teeming with boys and girls devastated below the waist by polio, every one of them hobbling on stick-like legs, trussed in calipers or balancing on crutches? Can you ever forget the sight of scores of crippled children proudly participating in Republic Day parades in Delhi?

Those of you who lived through the polio epidemics that swept through industrialized countries between the 1900s and mid-1950s, do you remember the terror—the tens of thousands of children and adults paralyzed, and the thousands killed? Do you remember the times when children were not allowed out of their homes because no one, not even medical specialists and health officials, really understood the mystifying ways in which this contagious disease spread? Remember the swimming pools, movie theaters, churches, and amusement parks that closed down every summer because people feared contamination in public places? The hospital rooms filled with huge machines called iron lungs to help the polio-afflicted to breathe? The pessimism of doctors faced with a disease that couldn't be predicted, prevented, or successfully treated? And do you remember that not so long ago polio made the news almost every day, and nearly everyone knew someone who had been touched by the disease?

Having sought out the facts, I carry an encyclopedia in my mind of the cataclysm wrought by polio. The world has some twenty million children and adults with severe life-long disabilities caused by the disease. Twenty million people—a number equal to the entire populations of Afghanistan or Australia. A full third of France or the United Kingdom. Cuba and Haiti combined. Nearly three Switzerlands. Twenty million people robbed of the joy of walking, most of them at such a young age they hardly had the chance to experience it. Twenty million people disabled and condemned to suffering for life.

I remember vividly, from visits as recent as 2001, hospitals in India and Africa overflowing with young kids no more than three or four years old, with wasted legs, withered arms, twisted spines—waiting for agonizing operations that might untwist them, perhaps let them stand, even possibly let them walk using crutches or wearing calipers, but that only rarely would allow them to walk freely. I remember India's handful of schools and homes for disabled children so completely overwhelmed by this unending tide of disability that they could help only a tiny fraction of polio sufferers, leaving the rest to waste away.

I remember being accosted at a street café in Brazzaville, the capital of the Congo Republic, by a flock of crippled children riding on rough little boards on wheels, begging, beseeching, pleading. Some were teenagers, others no more than 8 years old, but all of these unfortunate, unkempt, dirt-poor boys and girls were harshly crippled by polio, their atrophied limbs and torsos twisted this way and that. I remember leaving those children with my pockets nearly empty, but still sickened by my failure to not do more for them.

With the most acute agony, I remember meeting Brij Lal in December 1994, in a small village in the north of India's Gangetic plain. Then in his late teens, Brij Lal looked nothing like someone approaching manhood, but like a shattered, grieving bird—a small, dusty figure with a skeletal face, vacant, gentle eyes and incomprehensibly soft speech. I had never seen such a severe case of polio paralysis—nor had I ever witnessed, so indelibly, the unconscionable suffering that is inflicted on the one billion people who still only rarely in their lives have access to even the basics of modern public health and medical care.

Both of Brij Lal's arms and legs were so badly wasted, they were nothing more than bones with some skin stuck on. His emaciated frame was so crushed together that he could only crawl a few feet on his own—and could barely turn himself from one side to another while lying down.

Brij Lal had been only once to a doctor, just months after he was crippled by polio as a young child. This rural doctor, possibly out of sheer helplessness, had brusquely told Brij Lal's mother to take the boy away because there was nothing he could do for him. In the fifteen years since that day, Brij Lal had not been seen or touched by a doctor or nurse.

Before dawn every morning, Brij Lal's impoverished, landless mother, widowed many years ago, fed her adored only son, washed him, and then carried him on her back to the path leaving the village, where she left him propped up against a tree. Then she picked him up again when she returned at night from laboring, for a pittance, in someone else's fields. This is how Brij Lal had spent his life since being paralyzed.

(continued on page 108)

THE GLOBAL CAMPAIGN

Photographs by Sebastião Salgado

In 1988, 1,000 children became sick with polio every day. In 2002, the disease struck fewer than 2,000 people in the entire year.

The photographs presented here show some of the mass campaigns to immunize children against this disease in five countries at high risk of new outbreaks or where polio was still endemic in 2001—the Democratic Republic of Congo, India, Pakistan, Somalia, and Sudan.

They also document the devastation caused by the disease. And, they portray some of the millions who have contributed, in most cases as volunteers, by transporting the vaccine, immunizing children, and tracking new outbreaks. In certain instances, armed guards have been needed as well; a few health workers have been killed during the campaign against polio.

These photographs are part of a movement among documentary photographers to not only witness the world's problems, but to try and use their imagery to help solve some of them. Sebastião Salgado, the author of these images, said, "The people with whom I worked on this campaign have the same values that I do as a photographer."

By the year 2005, it is hoped that the disease of polio will have been eradicated.

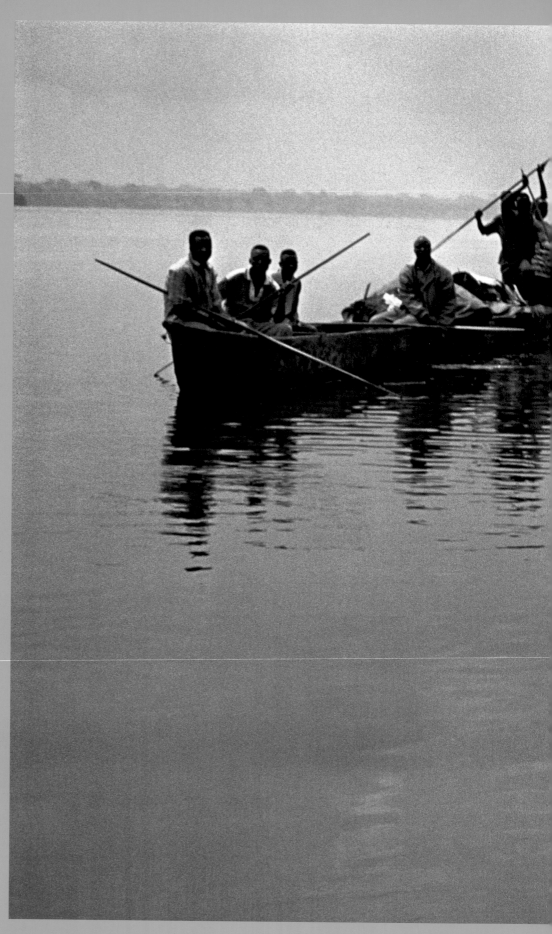

DEMOCRATIC REPUBLIC OF CONGO

DEMOCRATIC REPUBLIC
OF CONGO, 2001
During a polio vaccin-
ation campaign, volun-
teers stop passing
canoes on the Congo
River in an effort to
immunize every child
under the age of five.

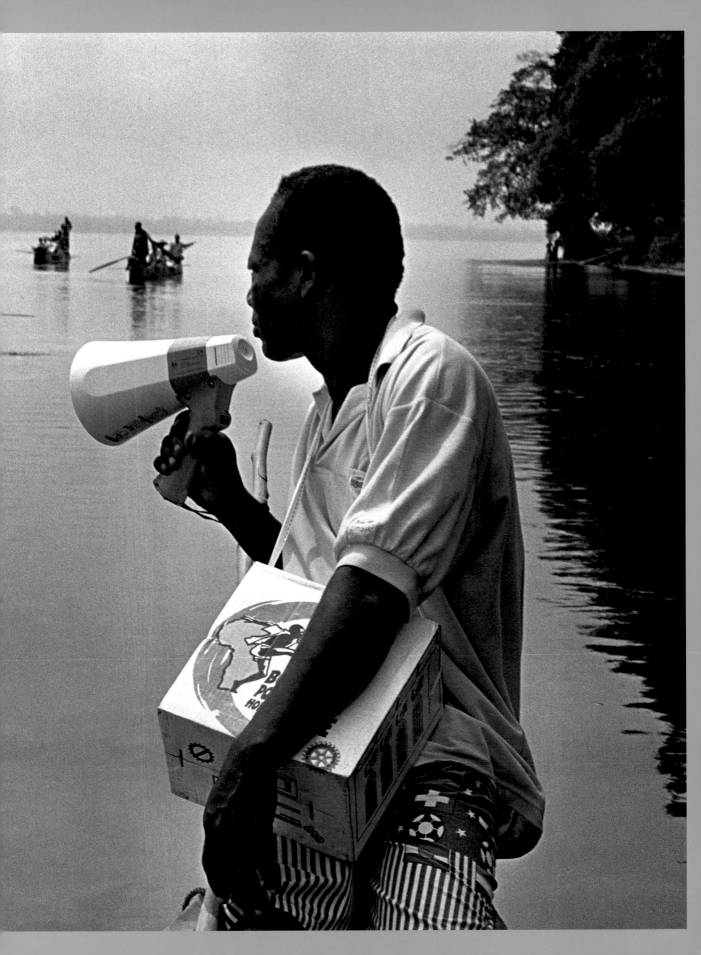

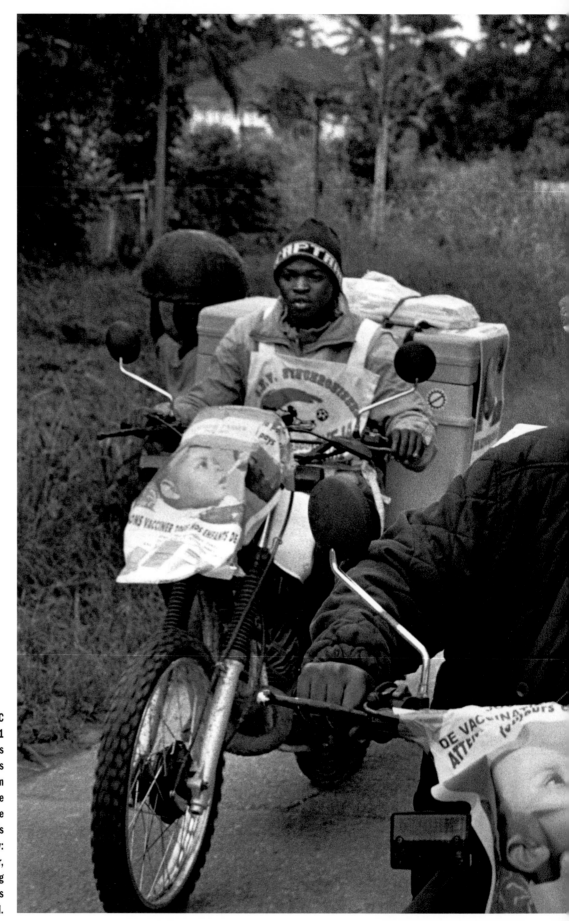

DEMOCRATIC REPUBLIC OF CONGO, 2001
Motorcycle teams transport containers of polio vaccines from Kisangani to remote villages in the equatorial forest. This is a risky journey: two weeks earlier, a doctor conducting immunization surveys was shot on this road.

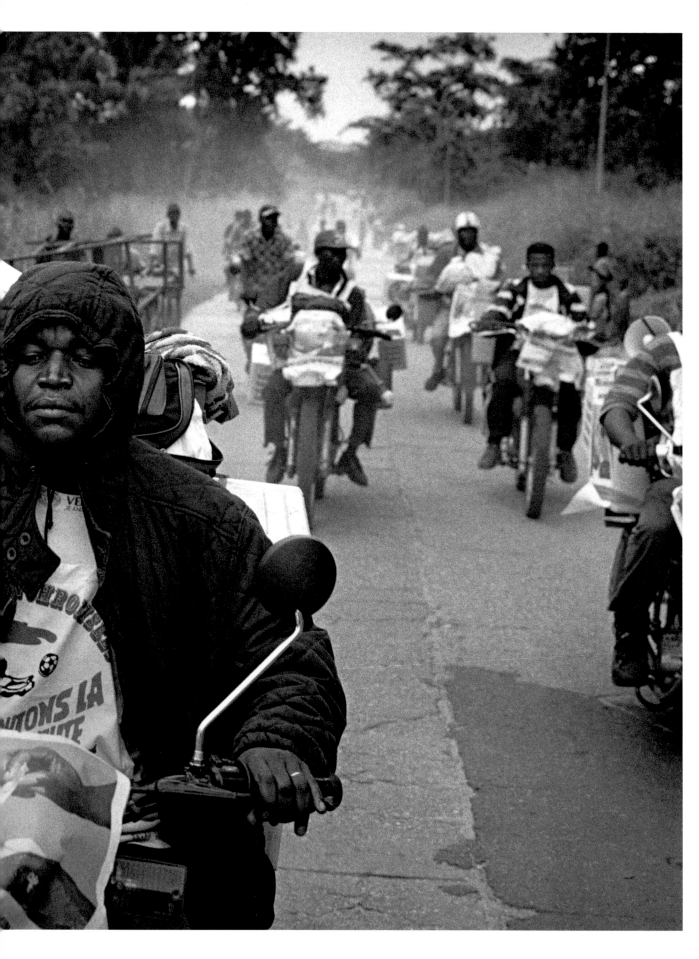

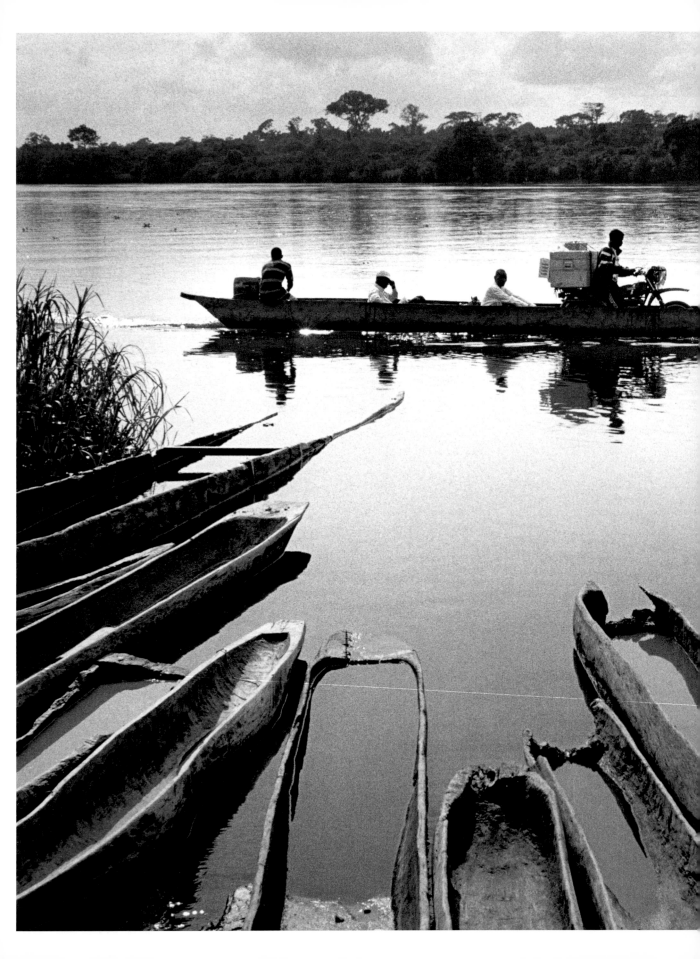

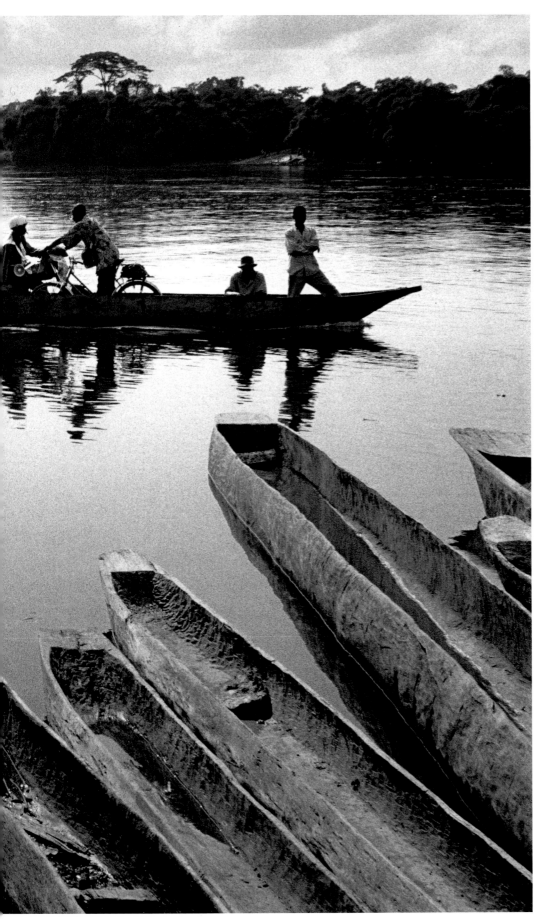

DEMOCRATIC REPUBLIC OF CONGO, 2001
Health workers who are part of a "cold chain" team cross the Congo River. They load their bikes and vaccine containers onto the boats as well, so that they can continue their work on the other bank.

DEMOCRATIC REPUBLIC OF CONGO, 2001 War has destroyed most roads in the Kisangani region, forcing the majority of the population to settle near the river for easier access to food and water.

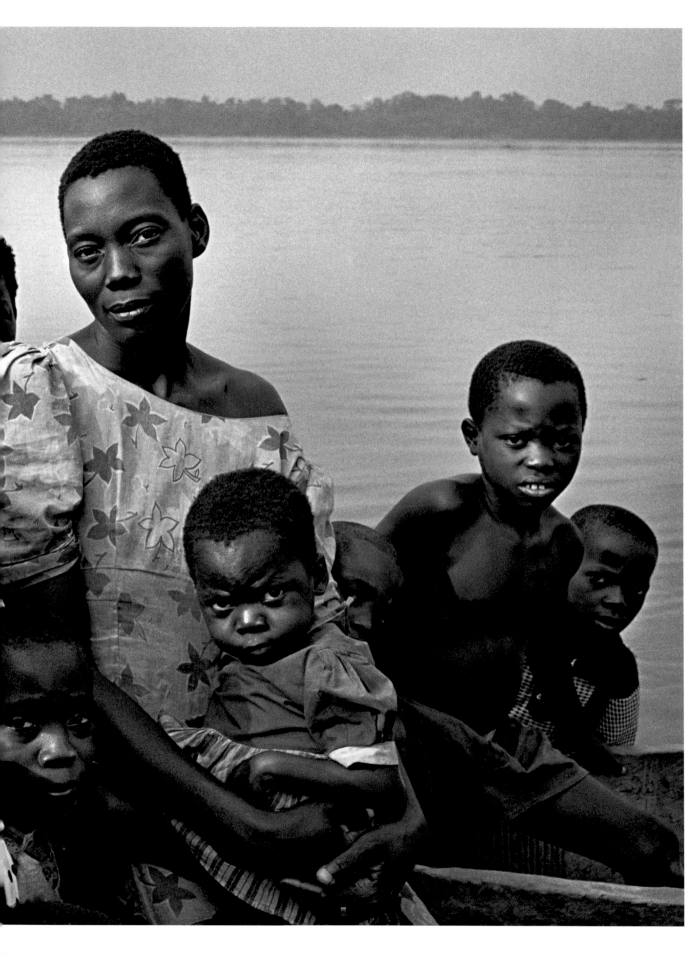

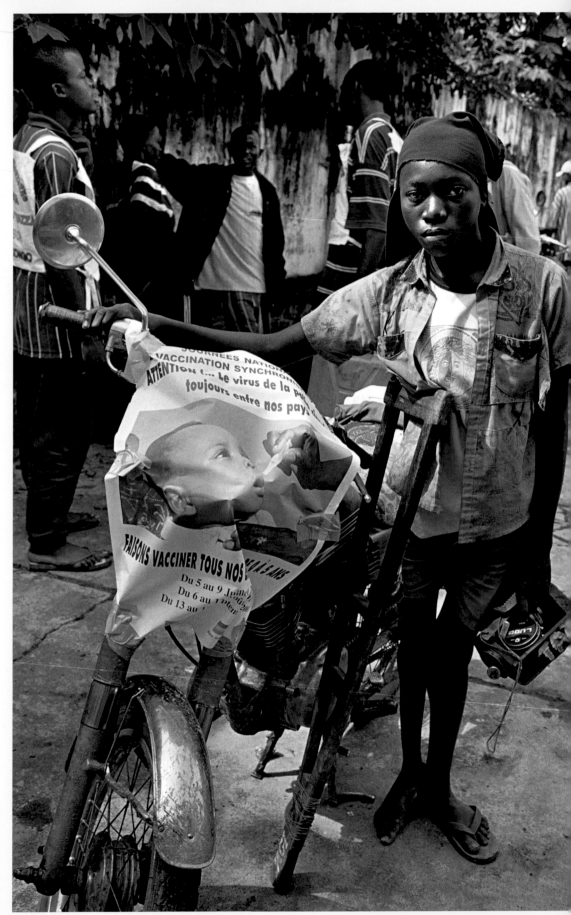

DEMOCRATIC REPUBLIC OF CONGO, 2001
A girl displays a sign during the information campaign for the National Immunization Days in Kisangani.

CHILDREN ON THE RIVER

Kinshasa and Kisangani, Democratic Republic of Congo, July 2001— Sophoclis Orphenides has come to the Kisangani Rehabilitation Center to seek relief from some of the pain in his legs. The 29-year-old mechanic, whose father is Greek and mother Congolese, moves around with the help of crutches, his legs withered and paralyzed by a childhood bout with polio. He moves slowly among other victims of polio, some on crutches, others on hand-cranked tricycles.

Orphenides vividly recalls contracting polio. His family lived on a remote coffee plantation in the eastern jungles of what was then Zaire, now the Democratic Republic of Congo. "I used to play football, run around. Then I got measles, and after it polio. A Belgian nurse told my mother I wouldn't walk again. But my mother didn't believe it. She took me to another hospital. She thought the sickness would end." The fever that accompanies the onset of polio did end, but the virus left him paralyzed. He was five years old. He had never been vaccinated.

While Orphenides receives therapy at the rehabilitation center, health workers and volunteers are making last minute preparations for a countrywide polio vaccination campaign, scheduled to start the next day. Nearby, a local television personality named Makulu Kulu puts the final touches on a clown costume, which includes a dunce hat made out of polio immunization posters. He then hops on the back of a pick-up and rides around town, telling people the campaign is imminent. As Makulu Kulu smiles and children laugh and chant his name, the driver continually shouts through a loudspeaker the word "*mangwele,*" which means vaccination in the local language, Lingala. The children respond with "*buka buka,*" slang for polio.

Congo is one of the largest countries in Africa, a vast swath of jungle and savannah encompassing an area the size of western Europe. Its massive size, limited infrastructure and endemic conflict turn vaccination campaigns into Herculean efforts. The 2001 National Immunization Days are targeting nearly 12 million children under five and require 43,500 two-person vaccination teams, 20,000 supervisors, and 20,000 "social mobilizers."

Months of preparation are needed before the vaccine is actually administered. The burden falls on Congo's 307 health zones, some of which are larger than entire countries, such as neighboring Rwanda. Zone health officials must count children, determine their equipment and transportation needs, and submit plans to the

national organizing committee. Simultaneously, the national organizing committee must find the funds to run the annual campaign—$33 million per year.

About a month before the first of the three rounds, things move into high gear. Vaccine is pre-positioned across the country along what is called a "cold chain" — a series of relay points where the polio vaccine can be kept at –20 degrees centigrade. With Congo split between the government and rebels, the campaign requires two separate cold chains. Vaccines are often flown directly from manufacturers in Europe to the main vaccination storage facilities: the capital, Kinshasa, and Goma, the volcano-encircled eastern gateway to the rebel areas. The vaccine moves down the cold chain in large insulated transport boxes. The boxes are filled with 1,700 vials of vaccine, equaling 34,000 doses, and lined with thin plastic containers of frozen water. Sealed, the boxes will keep the vaccine potent for up to seven days. Less than a week before the campaign starts, the vaccines make the final journey to villages across Congo by any means possible: car, boat, bicycle, or even foot.

In a country with few roads, many children are reached by canoe on Congo's labyrinthine river system. We join 24-year-old nursing student Elise Litemba for such a journey on the Congo River just west of Kisangani. She and her team float down-river in rough-hewn canoes, calling through megaphones to villages dotting the shore. Their job is to mop-up, looking for children missed by regular teams. As people constantly move between the river's edge and fields deep in the jungle, children are inevitably missed.

A vaccination campaign's success hinges on vaccination teams like Litemba's. Each health zone trains its teams in skills critical to polio vaccination: administering the drops, ensuring the vaccine is cold, informing families of the necessity of the campaign. In the days leading up to the mass vaccinations, they make maps of their territories, devise a plan for reaching all the children in three days, and coordinate with their health zone to get cold boxes, vaccine, and sheets to tally their results. Then they get on the road for days that can last from sun-up to sundown. And their work can be dangerous. In Congo at least two health workers have been killed because of the war.

Litemba's team methodically goes through village after riverside village. She smiles at times, jokes. Often, she is quiet, with beads of sweat betraying the humid conditions. Litemba says the days are grueling and she often must ask for food or water from villages along the way. But she enjoys the work. "I am studying to be a nurse, so this is good practical experience," she says.

From his office in downtown Kinshasa, UNICEF Representative Martin Mogwanje explains the difficulties—and triumphs—of mass immunizations in Congo. He talks about the war, which has claimed so many lives. The fighting has had a dramatic

impact on the polio campaign at all levels, particularly in the rebel-controlled east, which includes Kisangani. Many places are simply inaccessible.

But the polio immunization campaigns also affect the conflict. For the first three years of Congo's National Immunization Days, Mogwanje has led the successful effort to create "Days of Tranquillity": agreements by the combatants to halt fighting during the campaigns.

"We say to each of the official belligerents: we expect days of tranquility. They always say yes. They don't want to tarnish their names by blocking immunization," he says, illustrating the locations of the front lines with a sweep of his hand over a map. Mogwanje hopes Congo's united effort on polio can serve as a building block for peace. "In effect, you have a rebel regime working with a government regime on technical issues," he says. "(The polio campaign) brings the whole country together. By doing something for kids, it's an affirmation of Congo's future."

Just down the road from the UNICEF office is Kinshasa's Centre de Rééducation Pour Handicapés Physiques. Here, we meet Jonathan Msiala, stoic and silent, both his tiny legs in fresh white casts. Five years old, he contracted polio when he was two. His mother said that he started vomiting and doctors initially diagnosed meningitis. But Jonathan couldn't stand on his legs. Soon they knew it was polio.

The casts came from an operation conducted a month earlier, thanks to funding from a United States development agency. Doctors cut Jonathan's tendons, which had atrophied from disuse, and then re-joined them. The operation straightened his legs enough to fit into braces. As we talked with his mother, Jonathan sat silently in her arms. "The operation was very, very painful. He is still suffering," she said. "But, before he could only crawl. Now, he will be able to use crutches and go to school."

Brother Pauline, the head of the center, tells us that because of the mass vaccination campaigns, cases of polio have dropped dramatically. Jonathan is one of the youngest polio victims in the compound. "When I arrived 20–25 years ago, we saw 20 new cases of polio daily. Once, this center only did operations and therapy for polio. Now, about 5 percent of our cases are polio." Very soon, he hopes, there won't be any at all.

By Mark Dennis

DEMOCRATIC REPUBLIC OF CONGO, 2001
A small boy who was paralyzed by polio attends primary school in Kisangani.

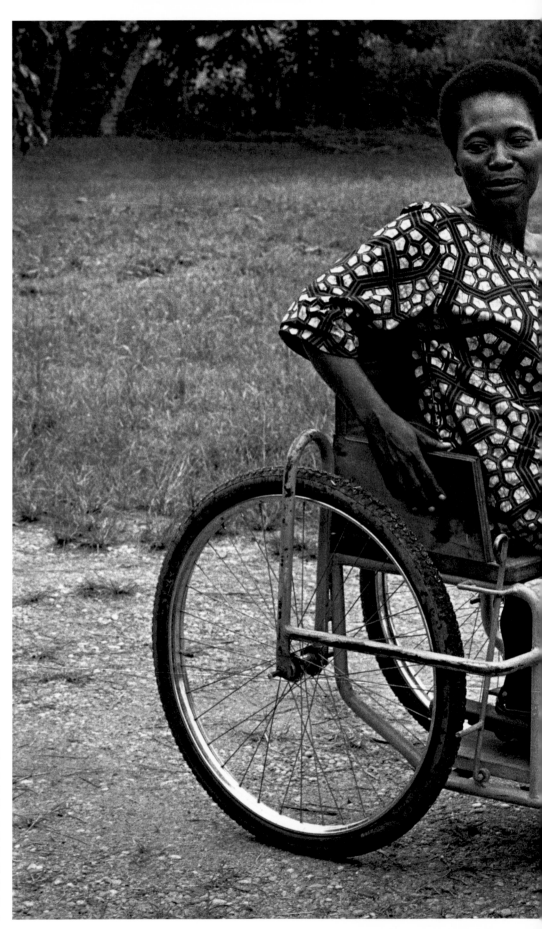

DEMOCRATIC REPUBLIC OF CONGO, 2001
A disabled woman bicycles at the Kisangani Rehabilitation Center, which was established in 1985 to provide medical services and training workshops for people disabled by polio and other diseases.

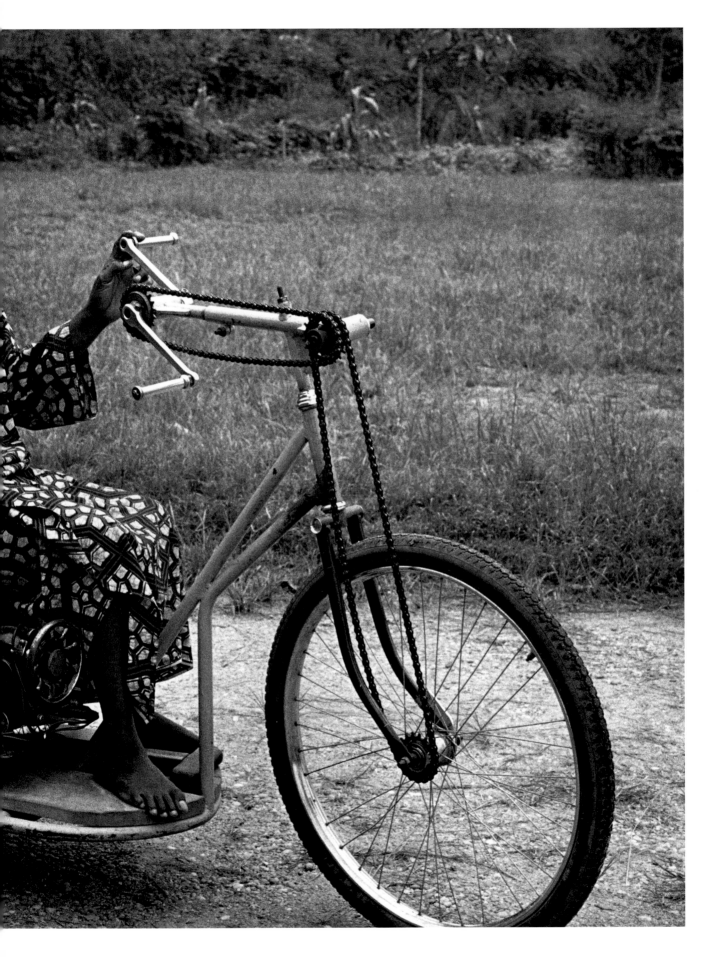

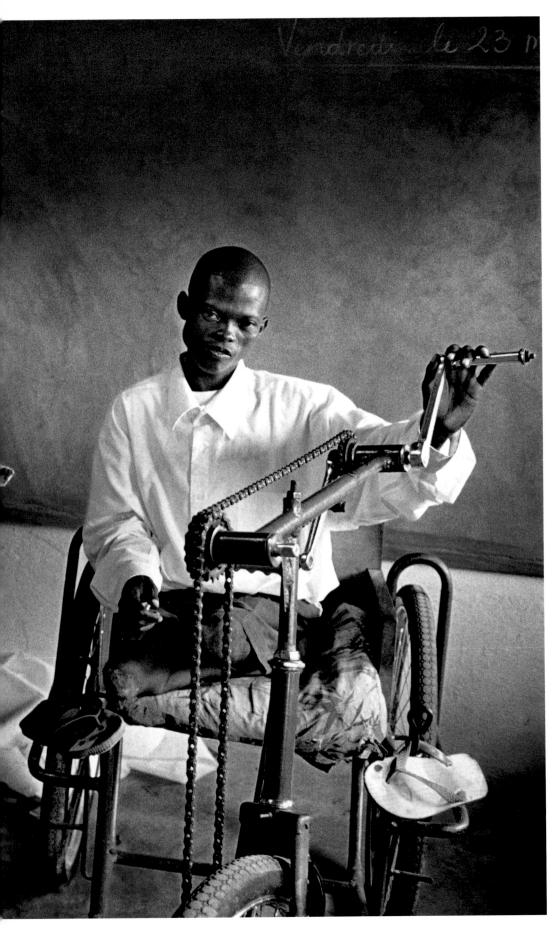

DEMOCRATIC REPUBLIC OF CONGO, 2001
Workers disabled by polio are in the workshop at the Kisangani Rehabilitation Center.

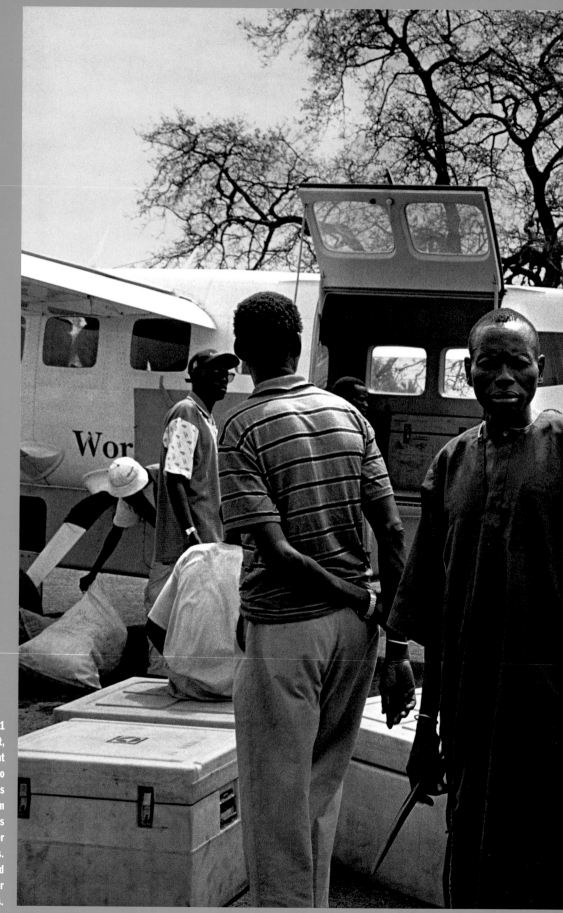

SUDAN

SUDAN, 2001
In Rumbek District,
a United Nations flight
carrying oral polio
vaccine is unloaded. As
the vaccine travels from
factory to child, it is
transferred from larger
to smaller containers.
It must be kept cold
at every stage or
it becomes useless.

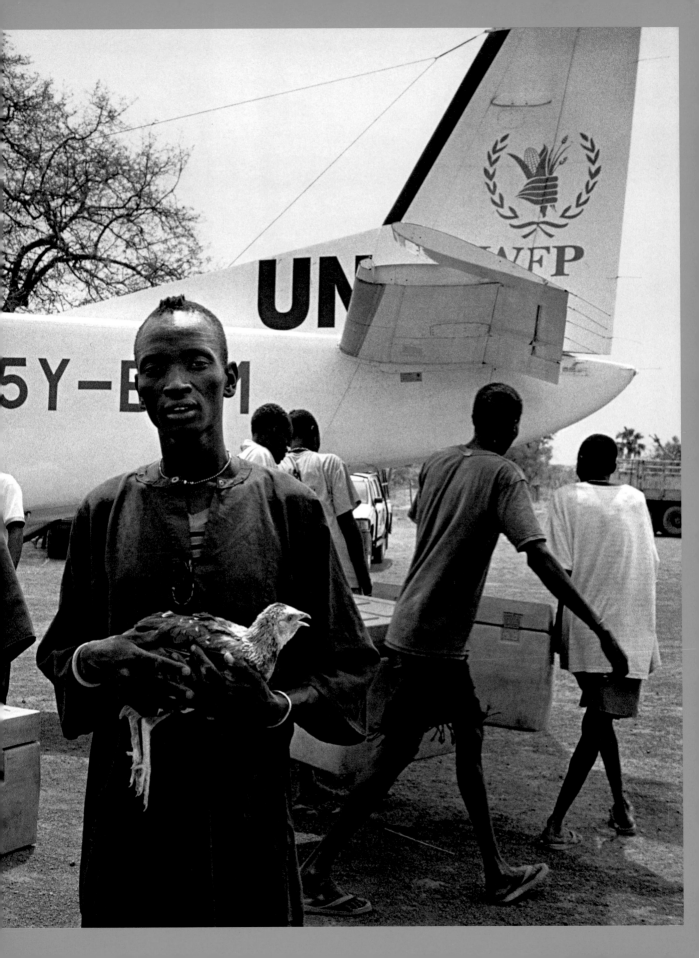

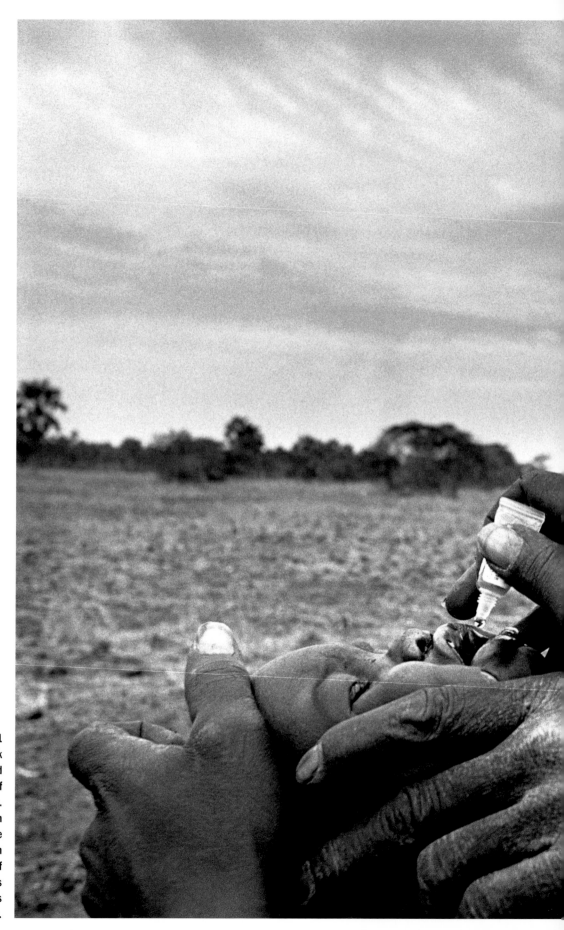

SUDAN, 2001
In Agepic, Rumbek District, a child receives drops of oral polio vaccine. Polio immunization and surveillance teams rely on United Nations relief flights to access remote villages such as this one.

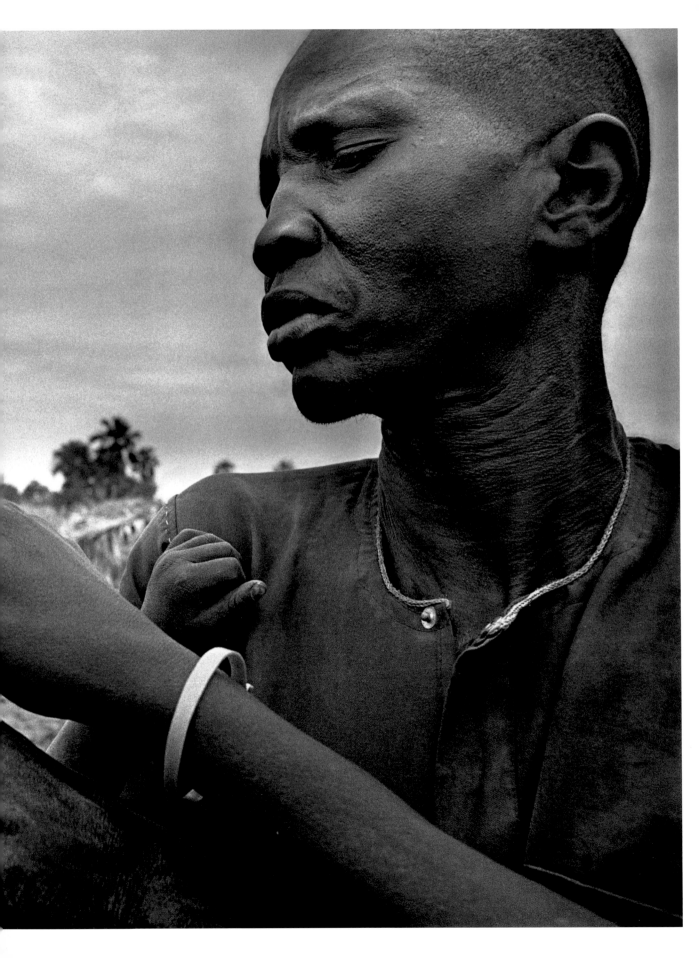

TRACKING THE LAST CASE

Pagol, Sudan, August 2001— I should have known that investigating this polio outbreak was not going to be easy. The team that had seen the case back in April had only been able to collect one specimen before fighting broke out in the area near Pagol, forcing them to evacuate. When I became involved, another team had already tried to make a trip to the area, but some of the airstrips near the sick child they were trying to reach were completely flooded and the Sudanese government had specifically denied the UN access to the others. The World Health Organization (WHO), UNICEF, and OCHA (the UN Office for the Coordination of Humanitarian Affairs) were trying to convince the Sudanese government to allow us to land on a dry airstrip, but things were moving slowly. The heads of UNICEF and WHO had also issued a statement asking local warring parties to allow our team safe passage. All this did not leave me with a good feeling, given that I was about to become the senior member of the WHO investigation team.

We waited a week trying to get clearance for the one good airstrip nearby and then decided that we would go to the only other known dry airstrip, even though it was at least a three days' walk from that location to where the child was. Another member of our international staff and I would fly up, the plane would drop us with supplies in Pagol, then go to pick up the rest of the team of Sudanese WHO staff. We went, but it had rained where the other half of the team was, so our Sudanese colleagues did not make it that day. I always feel uncomfortable being dropped in the middle of nowhere without knowing any of the locals, but that is exactly what happened. Luckily my colleague had at least spoken to the local administrator on the radio and he was there to meet us after the plane landed.

There was nothing in Pagol—where we were dropped—no real village, no wells, just an airstrip and three grass huts. We started at once trying to find out about the area and were soon talking to the County Commissioner. Soon after we began talking we heard the sound of a helicopter not too far away and then a series of explosions. We looked at our hosts, who assured us that this was not a problem but something happening far away: "just some bombs," they told us.

A few hours later the local authorities asked us if they could use our radio to contact the Red Cross to arrange a medical evacuation for a small girl who had

been seriously injured in the bombing, no more than an hour's walk away. The bombing had been caused by a helicopter gunship that we were to become all too familiar with. The next morning we again heard the gunship pass close by. I was already becoming quite good at cowering under trees. Luckily our Sudanese staff arrived the next day; having folks around who can speak the language and who will tell you what is really happening makes a big difference. There were no NGOs working regularly in the whole county, and with good reason. It was clear that the local administration did not want to scare us or tell us anything bad.

We split into three groups so we could examine some children who reportedly were paralyzed and see if any of them might have polio. Also, we wanted to check other surrounding villages for cases. I went with a couple of Sudanese staff and walked for about an hour to reach the village of the reportedly paralyzed children. All three of them were paralyzed in both legs—two of them probably had spinal tuberculosis and the other nerve damage from an injection given for treatment of kala azar (or, leishmaniasis)—one of the many unusual diseases that is more prevalent in Sudan than anywhere else in the world. As I was examining the last of the children I noticed that the clouds were gathering. It only knows one way to rain in Sudan and that is in buckets. Within ten minutes we were slogging through ankle deep water, and then calf deep mud, all the way back to camp.

On the third day, the gunship again passed very close to our location and the local administration decided that it was not safe for the internationals to be hiking around, let alone traveling great distances to find a child who reportedly had polio. In addition, while everyone agreed that a Dinka could make the trip in three days, they thought a *kawaja* (foreigner) would take at least a week—if they could make it at all—given that there was a river to cross. This would mean walking through water that is neck-deep for a Dinka, almost all of whom stand over six feet tall.

Then we had an incredible stroke of luck. When the health worker from where the child lived had heard that we were not going to be able to land nearby, he started walking to us in Pagol with the mother and child. On the third day of our stay, they appeared. We were able to examine the child and review the history and assure ourselves that this was in fact a case of polio—the first case of laboratory-confirmed polio in south Sudan in two years.

We had brought soap and salt for barter when we headed out on the trip. So, after we finished talking to the mother, examining the little girl, and taking their picture we gave the mother as much soap and salt as she could carry. Then they headed back towards home—a two to three day walk—carrying the little girl, who would most likely never walk again. We could only hope that we would

be able to get back into the area to vaccinate children so that others might be spared her fate.

We still needed people to go to the area where the girl came from to see if there were other children with polio. Since the internationals had been told not to make the journey, we agreed that our national staff would start out alone the next morning. The plan was that I and the other international would fly out two days later and then return to pick up the team in a week.

That night I went to bed early feeling good that there was a plan to get me out of this place sooner rather than later. Besides, we had at least seen the index case, so I felt we had accomplished the most important part of our task. I slept so well that I slept through the whole battle. Apparently, from around 10:00 p.m. until early morning a battle raged with gunfire and shelling. When I awoke I found out that everything was on hold. No one knew the outcome, only that rebel troops had attacked a government convoy trying to supply one of the garrisons in the area. We were told that it would be better for our program if the government forces won, because if the rebels had won there was likely to be a lot of retalia-tory bombing, which would make it difficult for our team to cross to the other side of the battlefield. We were told that no one should leave the camp.

At 10:00 a.m., the Commissioner came by and said that he was still not sure of the situation but would return by 1:00 p.m. and let us know what was up. I wanted to know what our options were and was told that if we had to abandon our current location and run into the bush the next nearest airstrip from which we might be evacuated was a two-day walk away. No one was sure if we could be evacuated from there either, given that the government has been denying the UN access to it for years.

Well, then it started raining and it rained for four hours. One o'clock came and went with no Commissioner and no information. We were all a little tense, to say the least. I decided, and no one disagreed with this decision, that we should all plan on getting the hell out of there on the flight that was coming in two days. It was clear that the place was just too unstable at the moment to accomplish any of the things that we wanted our team of Sudanese staff to do. In addition, a couple of our people were complaining of illness, which was not helping with morale. I got on the radio and told our logistician that he needed to figure out a way to get us out of there. By the next morning, Friday, he said it was all worked out. If it stayed dry for 24 hours a plane would come that would pick up all nine of us with our supplies.

Friday was a day of bad news. A young man who had been taking care of us in our little compound found out that two of his brothers had been killed in Thurs-day night's battle. The husband of the woman who had been preparing our meals

had been wounded in the same battle. The reports were that the rebels had won but that both sides had suffered heavy casualties. In addition, the whole rebel army seemed to have moved into our neighborhood. Their commander even came by and said hello. Apparently, the little compound we were staying in was his, but he assured us that we were fine. I was not sure whether being in the middle of the rebel army made us safer or whether we were at the center of the bull's-eye. The local administration asked our Sudanese physician to come and look at the rebel casualties and help decide for whom they would request Red Cross evacuation. There were at least 50 wounded, and these were the ones who had survived the eight-hour walk from where the battle took place. We saw a dozen people who had been seriously enough wounded to warrant evacuation, but it would be at least a week before any of them were able to be brought out of there.

Later, we came back to our compound and interviewed several local men as possible future polio eradication staff, as it was clear that we would need local people to do most of the work in this place. After the interviews, we did a couple hours of training so that they could start collecting information on possible polio cases for us. Given those accomplishments and the fact that it did not rain all day, I was starting to feel a little better. Before retiring, I mentioned that this would be my last night in south Sudan and that I had enjoyed the work and most particularly the people, with whom I felt privileged to have worked.

Before I go into the next plot twist in this tale I'll give some sense of the day-to-day routine. I said that there was nothing in Pagol, but there were actually plenty of the things you would expect to find in a swamp. The mosquitoes arrived promptly at 7:30 p.m. every night, although once we started building campfires they only ate the parts of you not facing the fire. By 8:30 p.m. I would usually retire to my tent and spend the next thirty minutes killing the mosquitoes that had entered with me. I would wake just before dawn in order to call the flight office in Lokichoggio by 6:30 a.m. and give the weather and condition of the airstrip. If the pilots did not get this info they just cancelled the flight. Promptly at 7:30 a.m. the mosquitoes would disappear. But there was no relief—just a changing of the guard. As the mosquitoes left, hordes of flies arrived. There were many other strange and large bugs that shared our lives in Pagol, including four-inch long scorpions. Then there was the water. The water that was used for cooking, cleaning dishes, and bathing was taken from a place that can only be called a mud puddle. If it had rained recently and the cows had not been playing in it, then it was more water than mud. The rest of the time it was more mud than water. We passed it through a guinea worm filter and if we let it sit then it would reach a level of clarity equivalent to dirty dishwater. So that is the background against which life in Pagol played out.

Saturday arrived, the weather was clear, the airstrip was dry, and we were all happy at the thought of getting out of Pagol. The plane arrived and I asked the pilot whether he thought he could fit nine people and all of our stuff and he said, "put it on and we will see." Well, the plane started up and after moving barely fifty feet, the pilot turned around and said, "this is not going to work." We were told to take everything off the plane except one piece of baggage per person. As we sat down again the pilot counted heads and noticed that there was an extra one—there was a stowaway on board. Apparently a young man who was the local rebel radio operator was trying to get back to see his family, whom he had not seen in sixteen years, and had snuck onboard. The pilot threw a fit and the stowaway was cast out. We again began taxiing down the runway.

While this airstrip had the ability to dry fairly quickly, it was not smooth by any stretch of the imagination. As we reached the far end of the runway, the pilot was clearly not happy. As he started to turn the plane, one tire hit a soft spot and quickly sunk into clay up to its axle. We dug, we pushed, we gunned the engine, and we put sticks under the tire—still stuck. By that time we had quite a crowd of locals, so we attached a few straps to the plane and got everyone, more than 20 people, to pull, and out it came. We pulled it around to face the right direction.

By now the pilot had decided that he would take only five people. The rest of the team began hemming and hawing about who was going to get to go, and only the Sudanese doctor volunteered to stay. I dislike indecision and the stowaway stunt had also annoyed me so I decided that I was going to be one of the lucky five. Three-quarters of the way down the runway the pilot cut the engine. He just said "no." The five of us got off the plane. The pilot shook his head and said "I think I can do it with two people, no more!" I knew the other international wanted to get back to Lokichokkio to run a big meeting that he had set up. I did not like the idea of both internationals abandoning the national staff so I told them that I would stay, figuring that in two days they could send another plane and we could all get out of there. The plane headed off, bouncing down the runway, and finally got airborne. The rest of us who were stuck in Pagol were despondent.

My next thought was to get on the radio and get our logistician working on a flight to get us out of there. I pleaded our case, but a couple hours later we were told that the flight people were angry with us for saying that the airstrip was landable. They would not send a plane back to the location until Tuesday. We were at the mercy of the flight office, so all we could do was hope that the weather held. Right after the plane left us our friend the gunship again passed nearby and then a short while later a MiG fighter plane buzzed low over the area.

Sunday was a tense day because the rebels were using it to test all of the weapons that they had captured in Thursday night's battle. There were bursts of gunfire most of the day which people kept reassuring me was target practice. We had released the woman who was doing our cooking so that she could take care of her wounded husband, but that left us with two young boys doing our cooking. In Dinka culture men do not cook, so the quality of cuisine suffered dramatically when these boys took over. The Commissioner gave us a goat or sheep to slaughter every few days so there was not a lack of food, but I have to say that my appetite suffered on the day it was burned rice and goat tripe and the day it was lamb kidneys and ureters, served with burned *ugali* (cornmeal mush.)

By Monday the combination of stress, boredom, and despair was getting to me. Two of us went out to the airstrip to look at its condition in hopes that we would be able to give a good report and get our flight on Tuesday. The other medical doctor and I thought that it might help if we cleared some weeds. It was hot and by the end of the day I had drunk almost all of my remaining clean water. I had given my water filter to one of the team a few days before when it looked like the national staff was going to try to make the trek to the other side of the county. Unfortunately, the guy who had it left on the plane on Saturday.

I awoke extra early the next day to check on the weather and make sure that the report was given on the radio. There was not a cloud in the sky. We had had only brief rain on Sunday, so the airstrip was in as good condition as it could be. I was trying not to be too anxious or hopeful but began to understand the old adage, "there are no atheists in foxholes." The plane was due at 11:45 a.m. At 9:00 a.m. I called on the radio to check on its progress. There were now quite a number of unfriendly-looking puffy clouds around. We were all packed and ready to go. At ten we saw a big dark cloud advancing steadily. Our only hope was that it would miss our location and rain north or east of us. At 10:15 a.m. it started raining first slowly, and I hoped against hope that that was all that was going to happen. Then it opened up with buckets of rain. We were not going to be going anywhere that day. I was sitting in one of the grass huts feeling depressed when the rain started seeping in. Within a few minutes the floor of the hut was flooded by four inches. All of a sudden I saw this thing move—a rat was trying to stay on the wall above the water. I later saw its drowned body float by as the water receded. We set up our radio in another one of the huts and tried to reschedule the flight for another day. The Red Cross plane for the wounded, which was much bigger, flew in low to check out the airstrip but could not land and headed back, leaving all the casualties to continue waiting.

We were stuck again. The weather cleared in a few hours and again a MiG passed by. The big Antonov bombers were dropping bombs in the northern part

of the county, far enough away that you could not really hear but could feel the explosions. We would need it to be dry and hot for the next two days if we had any chance of making a flight on Thursday.

Wednesday morning was clear and we went back to pulling weeds from the airstrip. Now there was a group of local people helping and we were starting to make a little progress. Before noon the rain came in again. Luckily, the rain was brief and the sun came out strong in the afternoon. So did the Antonovs, passing overhead, which broke the concentration of weed pulling. The young radio operator, our attempted stowaway, asked whether he could try again to join us. It was very hard, but I had to tell him we could not risk the plane being too heavy due to the weight of an extra body.

The general morale of our team was not buoyant. We talked on the radio to one of the two who had made it out on Saturday. We were told that a bigger plane that would have less trouble taking off on the bad airstrip would come early direct from Lokichoggio and take us all back to Kenya. We were excited. The Twin Otter, as the plane is called, is a twin-engine prop plane that has the reputation for being able to take off and land on the worst airstrips. I drank almost the last drop of my clean water after pulling weeds. If we did not get out the next day I would need to start boiling the muddy water for drinking.

Thursday began clear and dry, but we had been down that road before. We were notified that the Twin Otter was not coming, but that the same single-engine plane that had only taken two people the previous Saturday was coming. All I could think to do was to go back to the airstrip to pull some more weeds. I figured that if the pilot saw that we had at least tried to improve the runway he would try a little harder at getting us out of there.

We were told that the plane was coming at 1:00 p.m.; but 1:00 p.m. rolled around, we were all out at the airstrip waiting, and still no plane. We set up our radio but could not get hold of anyone. I was starting to lose it, thinking that the plane would not show up. Finally we heard it coming: same plane, same copilot, but different pilot this time. This guy seemed confident, but after starting to taxi, he cut the engine. I was desperate—the thought of deciding who might have to stay was not a good one. The pilot and copilot got out of the plane and walked down the runway studying it. The copilot stayed at the far end to direct the turn and the pilot walked back. All the men were told to get out and walk down the runway to the far end. The plane turned and we all got back in. The plane took off down the runway at an angle, as he was trying to avoid a particularly rough patch, then cut back towards the middle. I didn't think we were going to make it, as it did not feel like we were going fast enough, but we kept going forward. We literally hit the grass at the end of the runway and the plane pulled skyward.

When we were off the ground all of us passengers broke into cheers and applause. We were finally making it out of Pagol.

We dropped most of the team in Akon, and there I was able to drink several liters of cold clean water. I was feeling much better and very happy. On the four-hour flight back to Kenya it was just me, Dr. Majok, our Sudanese doctor, and a small boy who was a medical evacuee from Akon. As we got close to Kenya the boy started asking Dr. Majok questions in Sudanese and I asked Dr. Majok if the boy had been on an airplane before. Dr. Majok said no, the boy had never been in a plane but what they were talking about was that the boy had never seen a mountain before. Although he knew the Dinka word for "mountain," he had never understood what its meaning was.

Well, we were back and very relieved. I made it to Nairobi the next day and somehow pulled off my meetings. I am finishing writing this story in a sleepy village off the coast of Kenya watching the boats sail by, drinking tropical fruit juice, and eating fresh seafood. In another week I will be in Cairo to debrief and in less than two weeks I will be home and registering for school.

By Chris Zimmerman

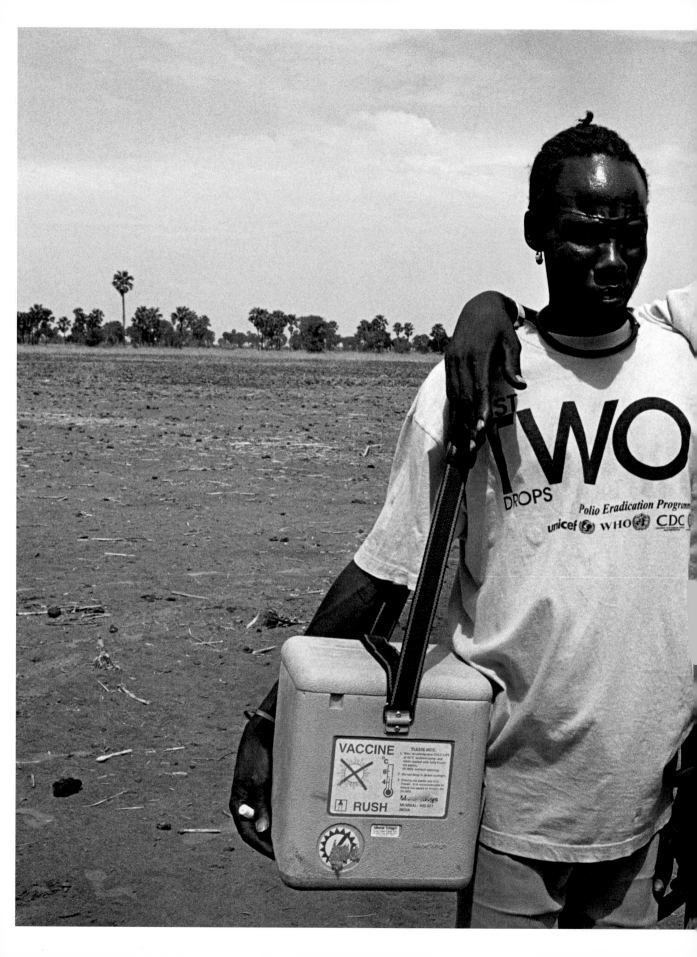

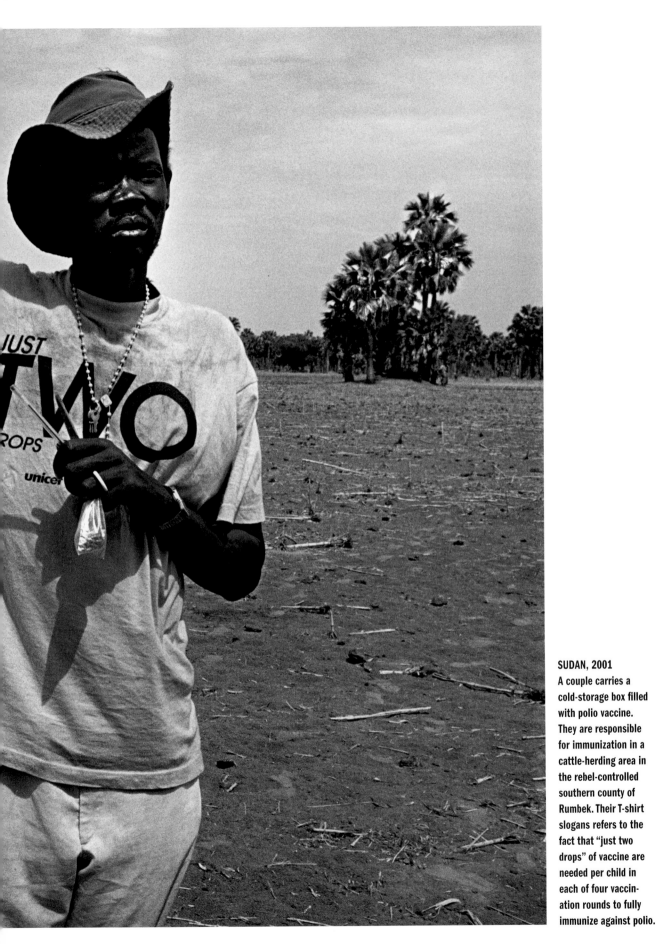

SUDAN, 2001
A couple carries a cold-storage box filled with polio vaccine. They are responsible for immunization in a cattle-herding area in the rebel-controlled southern county of Rumbek. Their T-shirt slogans refers to the fact that "just two drops" of vaccine are needed per child in each of four vaccination rounds to fully immunize against polio.

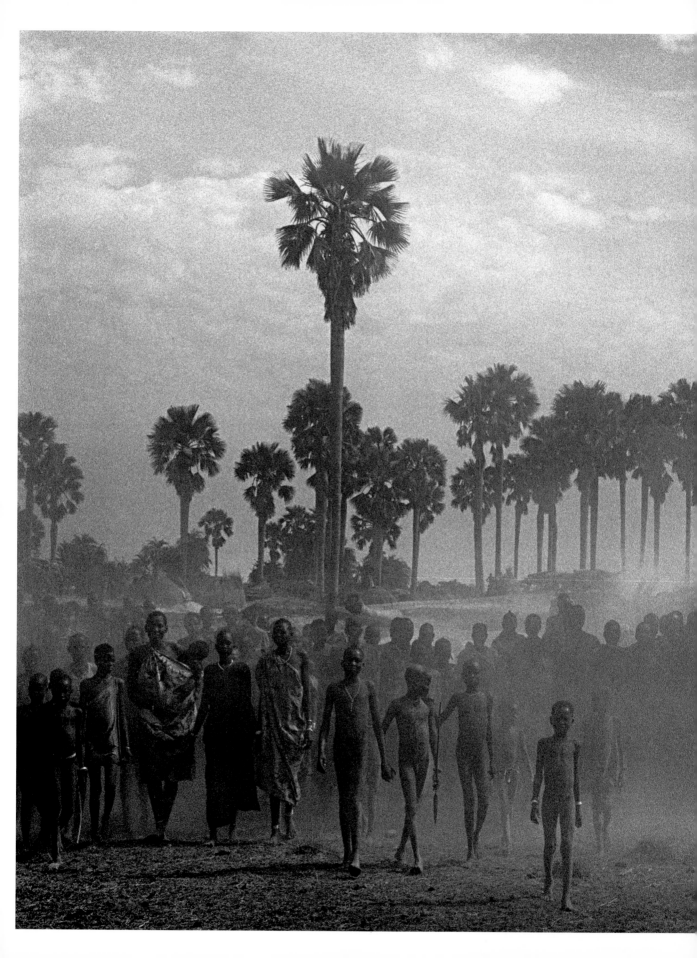

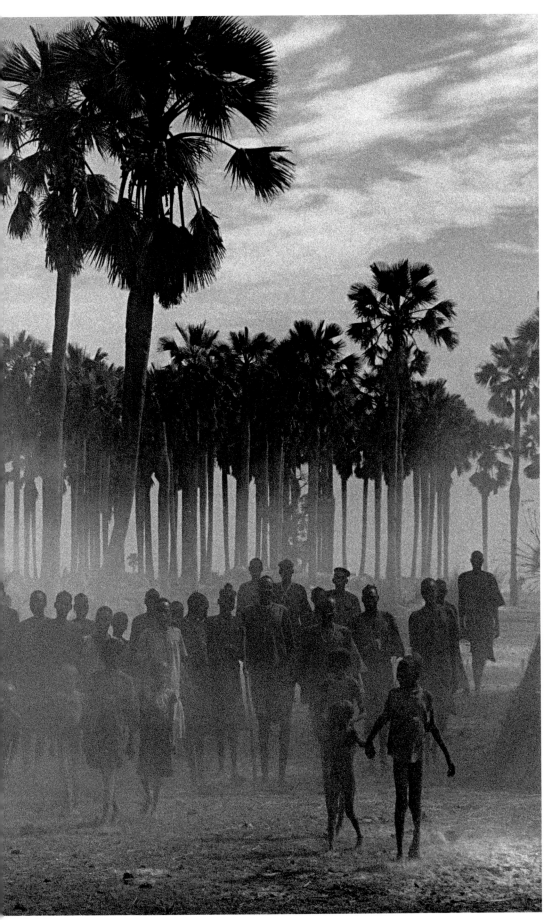

SUDAN, 2001
In the Maper Payem area of Rumbek District, the entire population of the Keny cattle camp walks towards an arriving team of vaccinators.

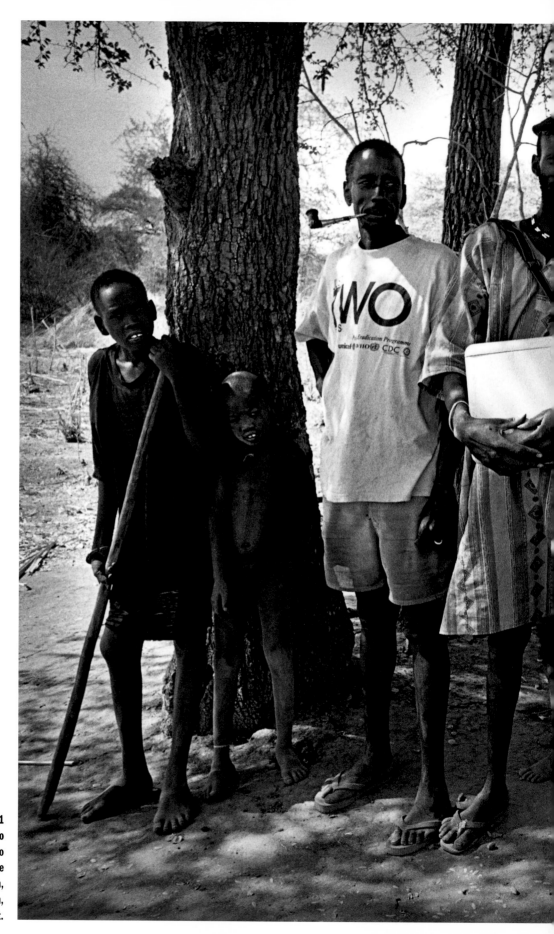

SUDAN, 2001
A team of polio
vaccinators go to
work in the village
of New Khartoun,
in the D'Alor Region,
Rumbek District.

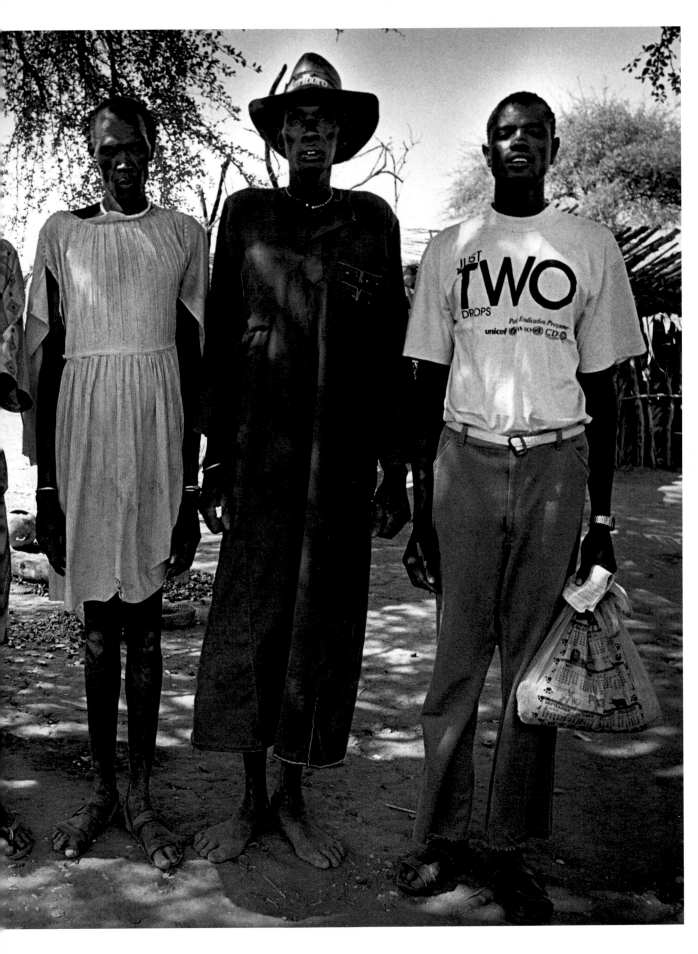

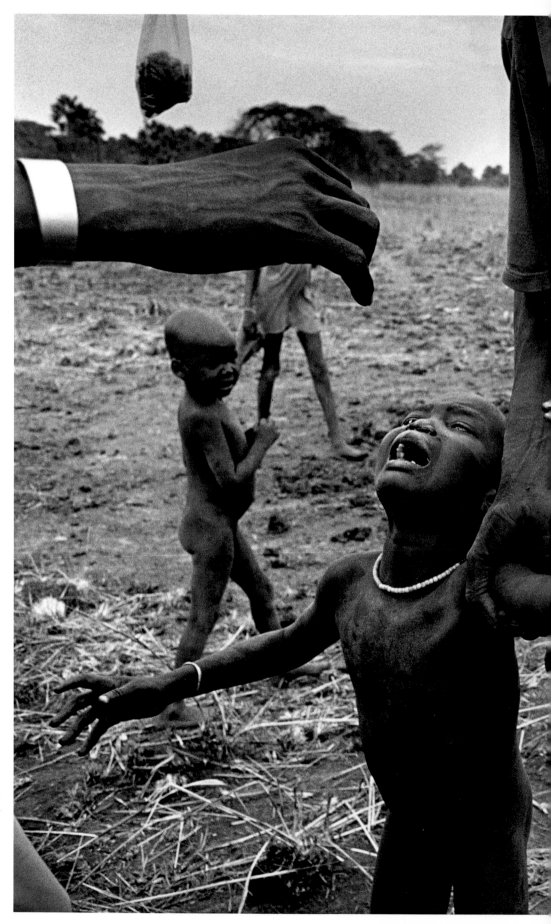

SUDAN, 2001
During polio vaccination campaigns such as this one in the D'Alor Region, health workers also administer doses of vitamin A, which helps boost the immune system and protect against blindness.

PAKISTAN

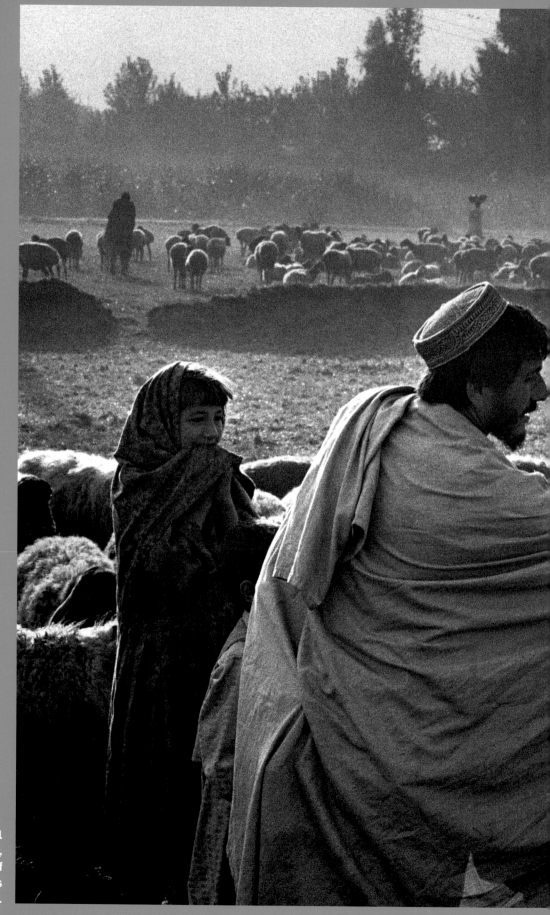

PAKISTAN, 2001
Near Peshawar,
children of
displaced Punjabis
are vaccinated.

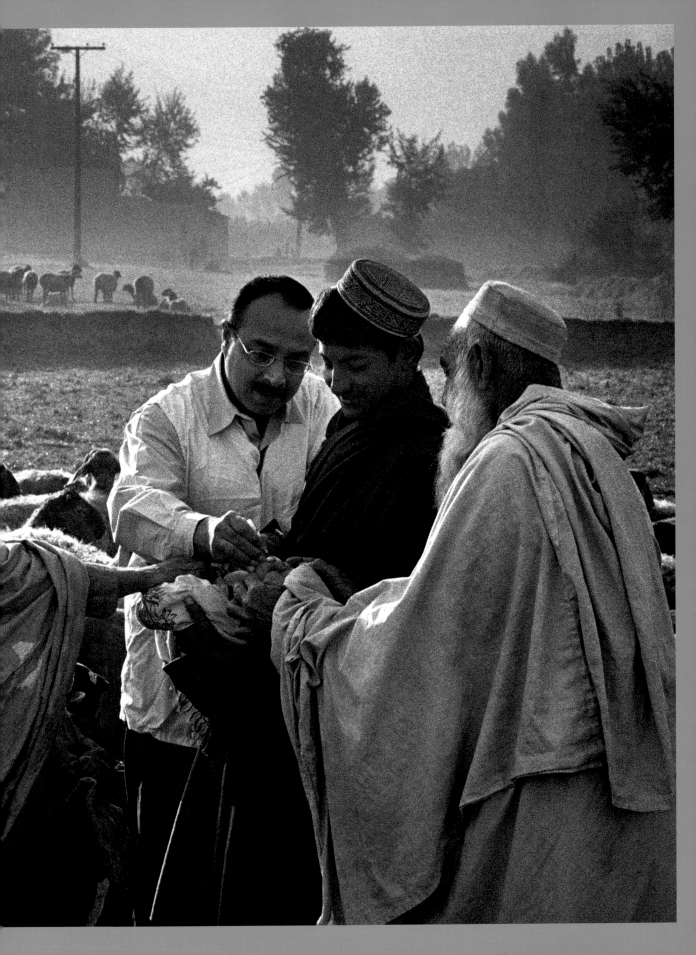

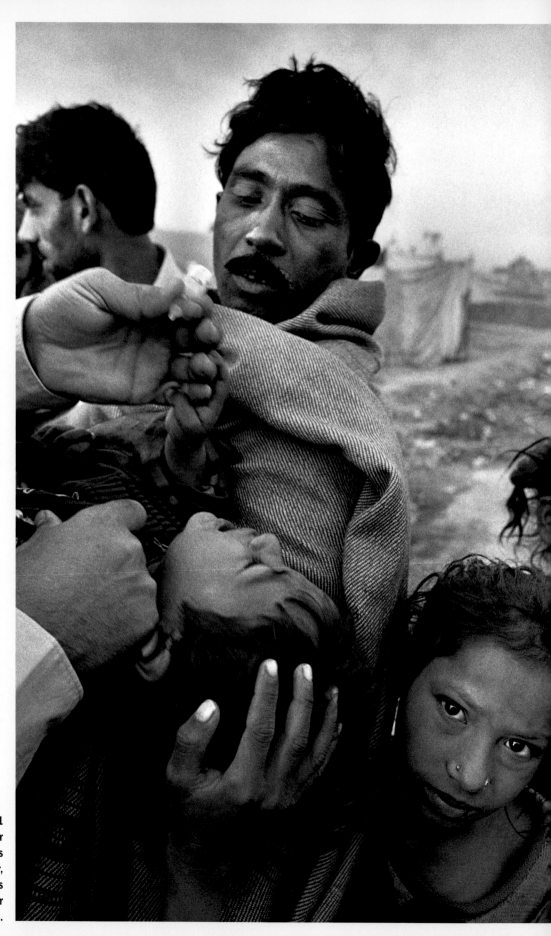

PAKISTAN, 2001
In a camp for displaced Punjabis near Peshawar, a father holds his child still for immunization.

PERILOUS BORDER CROSSINGS

Peshawar, Pakistan, October 2001— During the same month that the United States-led international bombing campaign in Afghanistan began, three truckloads of supplies left the United Nations warehouse in Peshawar, Pakistan's largest city bordering Afghanistan. They were headed for the more northern city of Chitral, and from there to a remote border crossing nearby which was one of the few still open for international relief traffic. I was part of a joint WHO and UNICEF team from Islamabad, Pakistan's capital, which accompanied the convoy.

Our truck was filled with vaccines and other supplies for Afghanistan's forthcoming November round of National Immunization Days (NIDs) against polio. All of the campaigns in Afghanistan are synchronized with those in Pakistan—targeting five million and 30 million children, respectively—because both countries share a common epidemiological "block" of poliovirus transmission, only one of three high-intensity transmission blocks left in the world. Our truck also carried other antigens and related items for routine immunization activities planned through the end of the year. Without these supplies, transported by this very convoluted route, both routine immunizations and NIDs in the provinces of Badakhshan and East Takhar would have to be stopped.

The trucks were decorated in the typical Pakistani style, with colorful details and costly woodcarvings, with WHO/UNICEF banners and other identifiers affixed for security. The convoy reached Chitral the day after leaving Peshawar. A UNICEF logistics assistant had already arrived by air to complete the permit clearances needed to send supplies and persons across the border at the crossing point outside Chitral called Shah-I-Salim.

From the Afghanistan side, a team from the provincial capital of Faizabad (where immunization efforts for the country's northeastern regions are coordinated), was making its way to meet us. Their journey took three days, including a one-day delay caused by a broken car and a seven-hour walk at an altitude of 4558 meters (14,954 feet) across the Shah-I-Salim Pass in ice-cold, heavy wind. They were bringing with them two stool samples of probable polio paralysis for delivery to the surveillance testing laboratory in Islamabad. Although their border crossing permits had been forwarded from the Ministry of Interior in Islamabad to the District Commissioner of Chitral, the Frontier Police denied them permission to continue. They spent the night in a bakery at Shah-I-Salim, a forgotten place with no hotels or sanitation facilities where temperatures routinely dip below freezing at night.

To help break the deadlock, the Faizabad team deposited the yellow box with the stool samples in the police officers' tent overnight, advising that the contents were very dangerous: wild poliovirus from Badakhshan that could spread if the box was not delivered to Chitral in a timely manner. In the morning, they were allowed to continue with a police escort, meeting up the same day with the Islamabad team and the trucks from Peshawar.

The next day, the entire group continued to the nearby village of Garam Chashma, again accompanied by the Chitral Police. Here, supplies were transferred from the trucks to jeeps. This was necessary because the only route to Shah-I-Salim is an extremely narrow and winding track that climbs to an altitude of 4,000 meters (over 13,000 feet), squeezed between bursting glacial rivers and steep mountains. In Shah-I-Salim, international tensions had caused the government to restrict all customary trading activities, so the pack animals necessary for negotiating the terrain on the Afghan side were not immediately available. It took another day to gather them. First priority was given to the vaccines in their cold boxes. Fourteen horses were loaded, with the other supplies stored under the supervision of locally contracted traders. The Faizabad team then departed on horseback with their cargo, making their way slowly uphill.

The trip was difficult; it took ten hours to reach the Afghan base camp. Twenty centimeters (about 8 inches) of snow had fallen, the horses often slipped and some of the cold boxes had to be carried part of the way by men. While the team had managed to rent vehicles for the final leg of the trip, some of these had broken down before reaching them. Finally, on October 28 all of the vaccines arrived safely in Faizabad, without any losses. It had taken six days—a record under these conditions.

The remaining items left behind in Shah-I-Salim, including emergency health kits sufficient to treat 30,000 people for three months, arrived in separate lots as transportation became available. The Pakistan team took only a day to return to Islamabad. Except for barely avoiding a run-in with another convoy—hundreds of trucks and buses carrying volunteer fighters, outfitted with turbans and machine guns, on their way to the Afghan border—their return was uneventful.

By Katja Schemionek

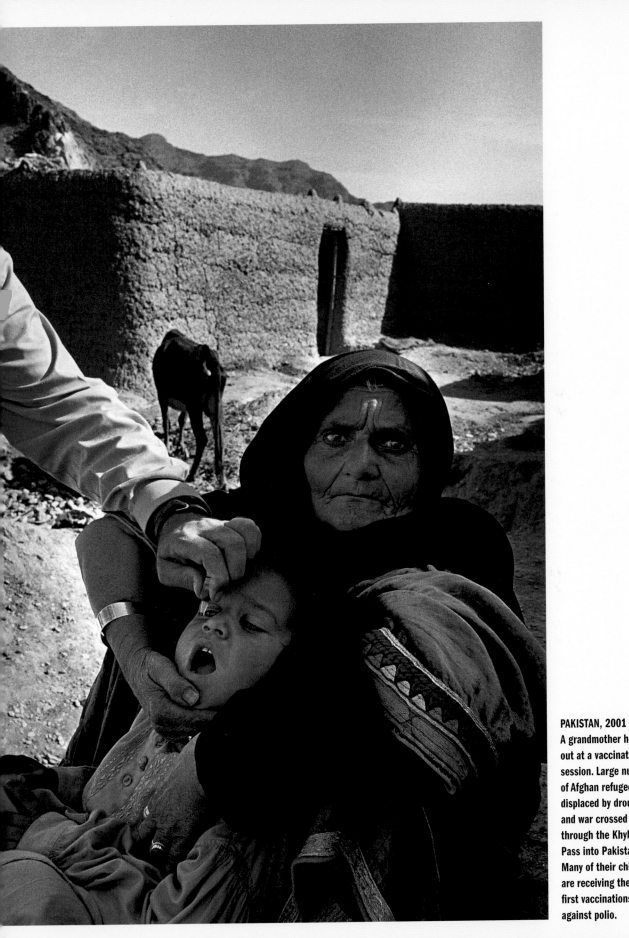

PAKISTAN, 2001
A grandmother helps out at a vaccination session. Large numbers of Afghan refugees displaced by drought and war crossed through the Khyber Pass into Pakistan. Many of their children are receiving their first vaccinations against polio.

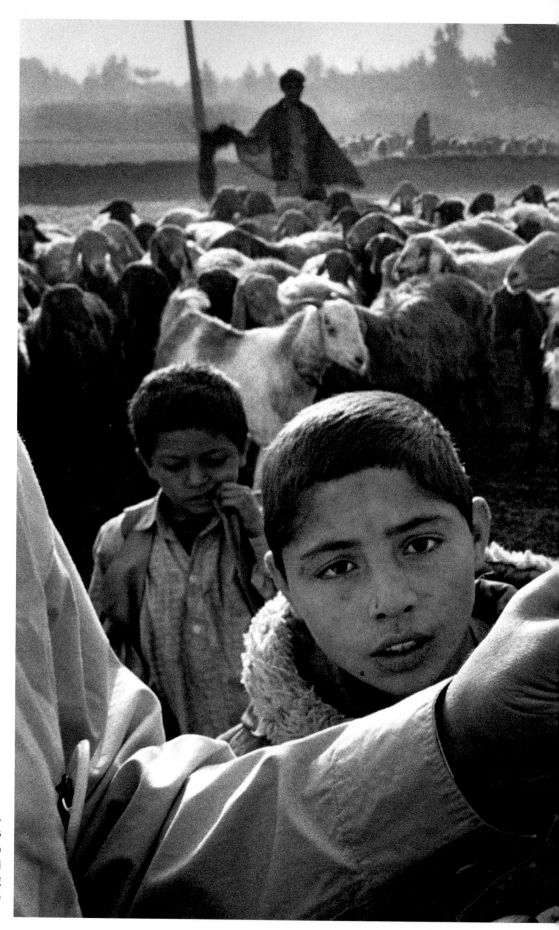

PAKISTAN, 2001
Polio immunizations
are administered to
the displaced Punjabi
population living
in camps in the
Peshawar periphery.

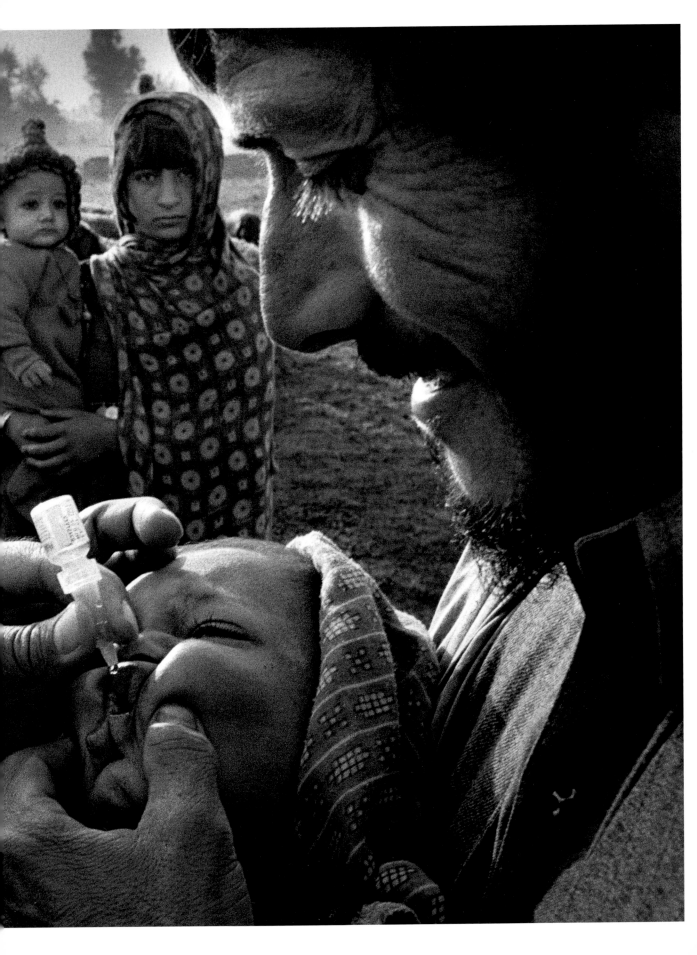

PAKISTAN, 2001
Young children from
the village of Rajo-Jo
Whandhio, Nagar Parkar
Region, Mithi District,
in the Thar Desert, near
the border with India's
Rajasthan State.

PAKISTAN, 2001
Jalozai camp, near Peshawar, is home to 50,000 Afghan refugees. Most of the people had come here a year earlier, fleeing a drought, but about 10,000 recently arrived, following the start of the U.S.-led bombing campaign in their country.

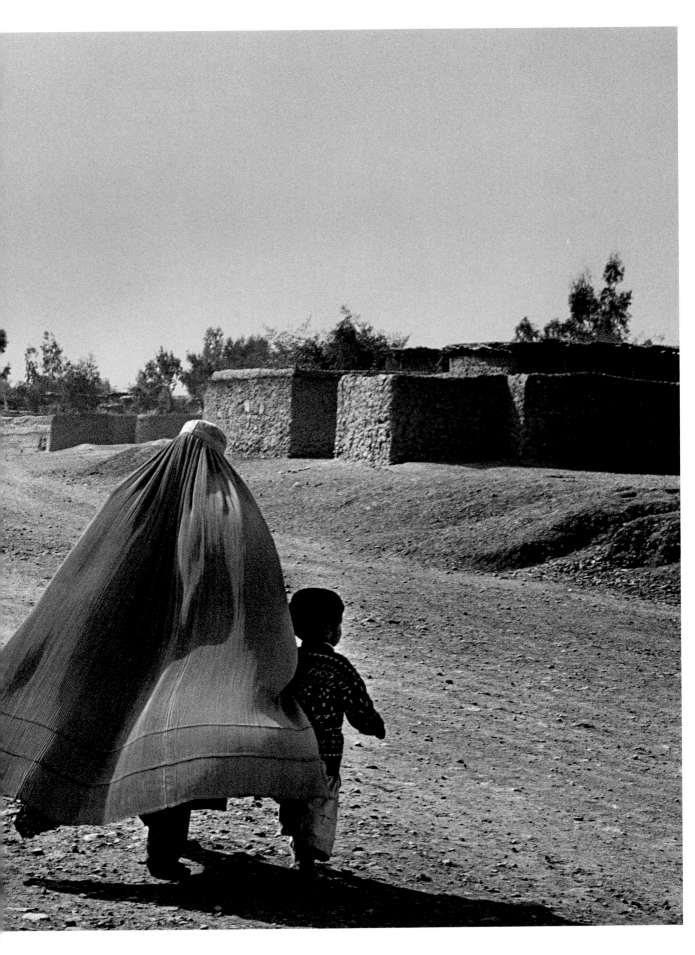

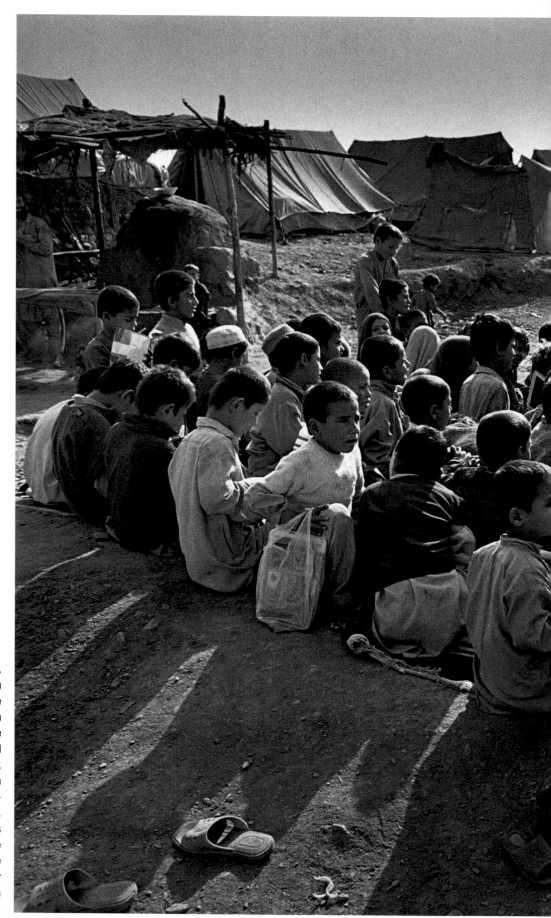

PAKISTAN, 2001
Children attend an
outdoor class in the
Jalozai camp for Afghan
refugees. During the
November National
Immunization Days,
access to Afghanistan
was cut off for interna-
tional immunizers.
However, health teams
on the Pakistani side
managed to immunize
Afghans at all major
border crossings and in
refugee communities.

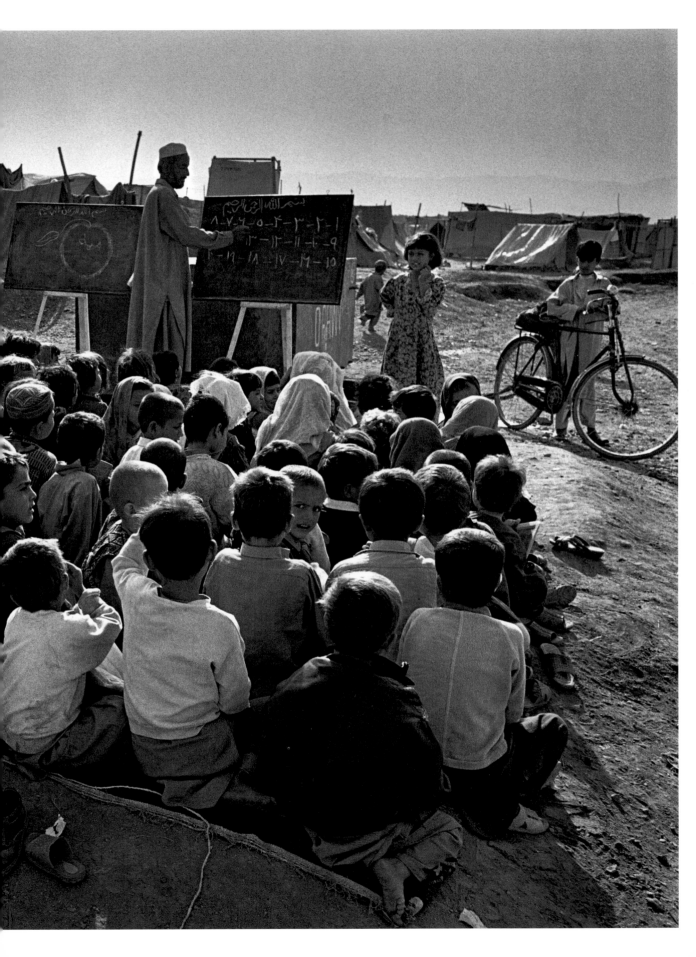

SOMALIA

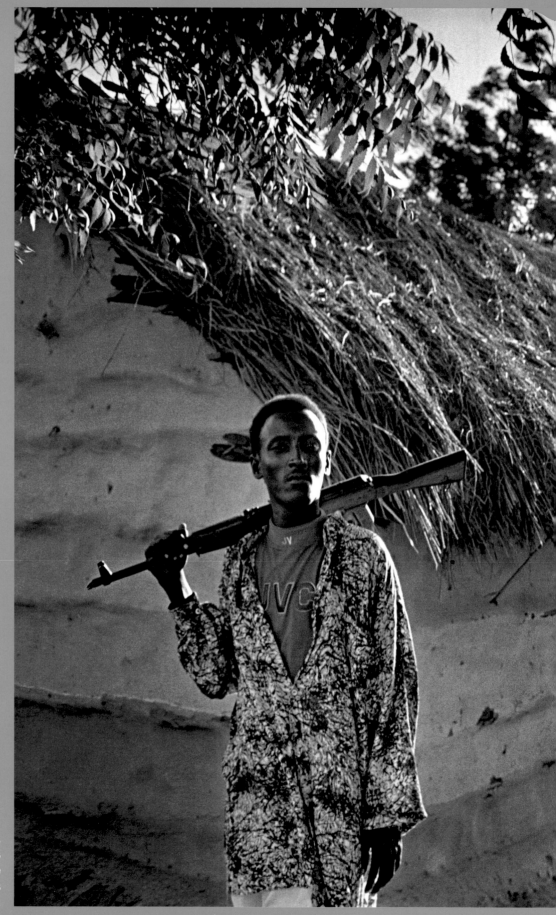

SOMALIA, 2001
Armed guards
accompany the
polio vaccinators
in Jamame.

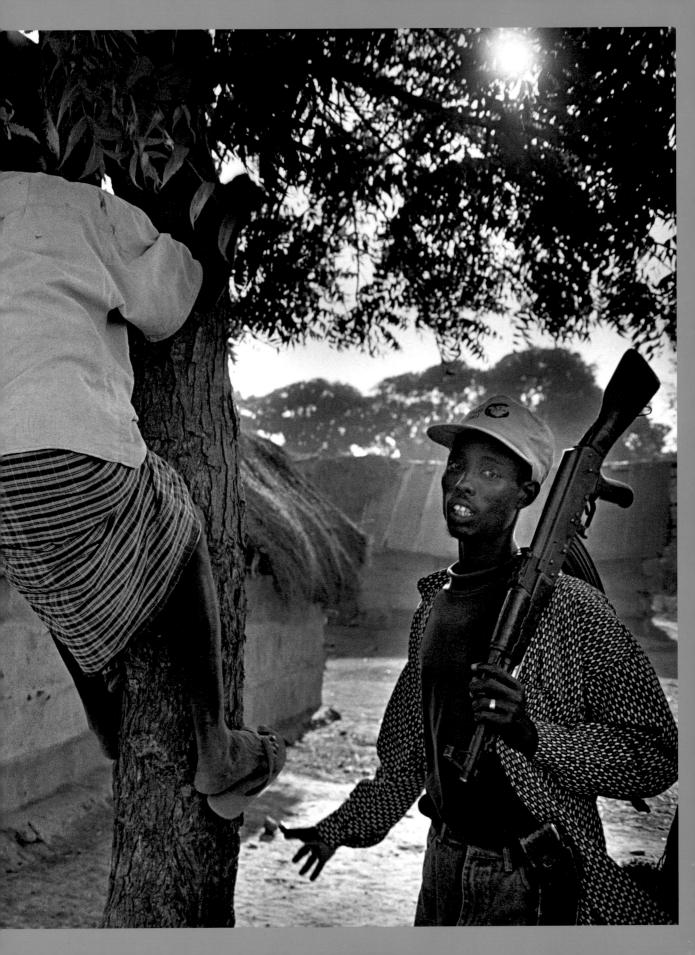

SOMALIA, 2001
Singers and musicians
are responsible
for the information
campaign for the
National Immunization
Days in Baidoa. They
play a crucial role,
motivating health
workers and convincing
parents to have their
children immunized.

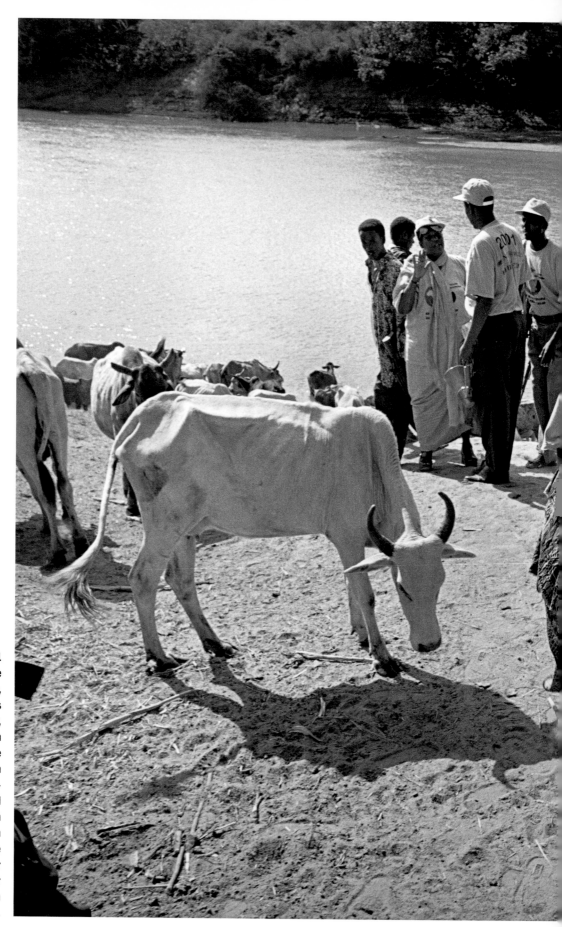

SOMALIA, 2001
On their way to the village of Aboorrow, health workers cross the Juba River, the border between two clans. Since communities often only allow immunizations to be carried out by their own members, health workers from one clan hand over vaccine to their counterparts in neighboring clans.

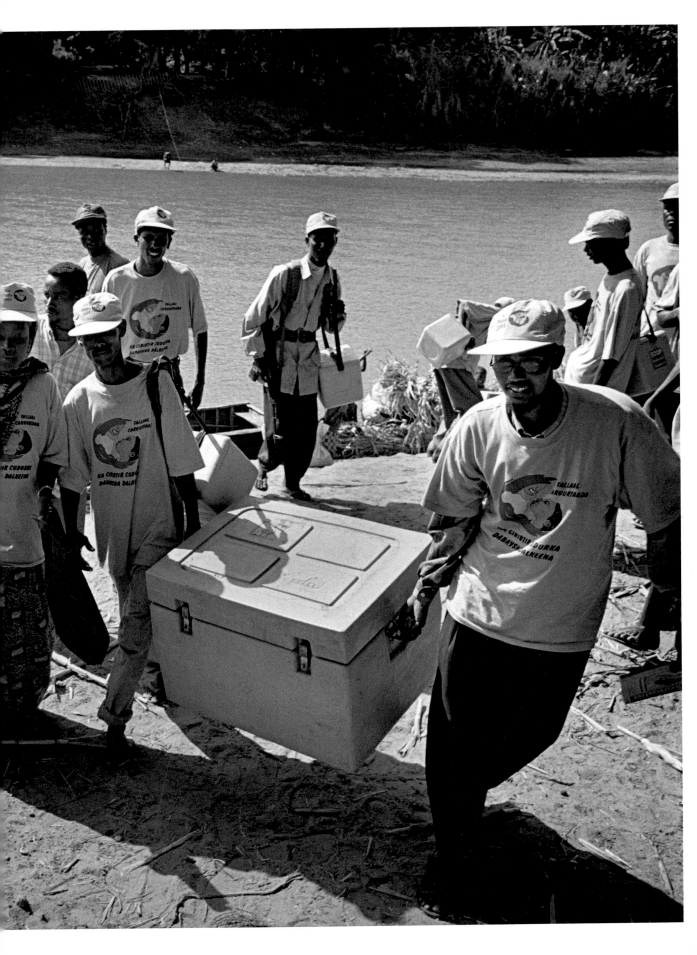

SOMALIA, 2001
In Gof Gudod, children
stand in the rain to watch
the vaccinators who have
come to their village.
It is the first time they
have received such a visit.

LINES DRAWN IN THE SAND

Baidoa and Jamame, Somalia, March 2001— I feel ill at ease the moment I step off the small airplane onto the dusty runway at Baidoa. Armed guards stand at the periphery of the "airport"—low white buildings stripped of roofs, walls, windows, and doorways during years of heavy inter-clan conflict. But while the air is hot and the atmosphere foreboding, World Health Organization and UNICEF staff are smiling, hands outstretched. "Welcome to Somalia."

Somalia—a country of wars, of countless clans, and tens of thousands of warriors. Wiry men, hardened by years of brutal fighting, squint into the sunlight, Kalashnikovs and rounds of ammunition draped over their thin, muscled shoulders. These are the men we hire for protection in Somalia. Five to ten of them, sitting in the back of our truck, nervously fingering their weapons and watching the horizon for the dust that signals another truck coming up the road.

But after speaking to them, and asking about the *Titanic* bubble-gum pack stickers they'd applied to their guns, I realize that they are just ordinary young men who had the misfortune of growing up amid some of the worst conditions on earth. Somalia is really a country of families surviving in a state with no government, on land hardened by the dry heat, in villages and towns littered with broken and looted buildings, garbage, and burned-out trucks.

Baidoa, also known as "the city of death," is full of ruins, once homes, businesses, government buildings, and gathering places, now half bombed-out, pillaged, with weedy grasses springing through cracks in concrete. Driving through, you have to wonder how people manage to survive from day-to-day, much less attempt to eradicate a disease like polio.

But hope springs a little further down the road, where dozens of people gather in a town square to watch local performers act out plays about polio in anticipation of the upcoming National Immunization Days. There are songs too—rhythmic and insistent. Later, hundreds more gather for a polio eradication soccer match. "No More Polio 2000," in yellow T-shirts, plays against the turquoise-shirted "No More Polio 2001." Here, too, armed guards stand ready. And while the soccer players deftly maneuver the ball across the red dusty field, an eleven-year old boy, Mohammad, drags himself in front of the crowd, hands grasping rubber thongs, dirty pads tied to his knees. Mohammad's legs have been withered and rendered useless by polio. Deemed too much of a burden, he has been abandoned by his nomadic parents.

Polio is one of many diseases that plague Somalia. The virus used to circulate freely in the country, leaving children like Mohammad paralyzed in its wake. But because Somalia had no health system to speak of, and certainly no surveillance

system for polio, health authorities didn't know how much polio there was, only that most every town had a child like Mohammad.

But despite the extreme and unpredictable conditions—a vaccinator was killed by a crocodile in late 2002—the clan rivalry and the broken-down everything, Somalis are on the verge of eliminating the poliovirus from within their borders. In late 2002 there were only three new cases in the whole country, all clustered around Mogadishu. The key to success, it seems, is community involvement and "ownership" of the effort, essential for each Somali clan.

In general, clan leaders only allow members to immunize their clan's children. Clan boundaries are obvious to Somalis, but to the outsider they can be mystifying—lines drawn in the sand. It is over these lines that program organizers must enter into delicate negotiations—renting one clan's truck to deliver vaccine, driving it a few kilometers, and then stopping, unloading it, and reloading the cargo into an opposing clan's truck to carry on the work. But while tenuous at times, the system works.

This was demonstrated wonderfully at the Juba River, in southern Somalia near Jamame. Our trucks drove down to the river, where the guards and vaccinators unloaded and carried the vaccine down to a waiting ferry. The ferry, a shaky looking rusted boat, was loaded with vaccine and people, and as the ferryman pulled his charge across the river, the vaccinators and guards sang the Somali national anthem. Waiting on the other side was the rival clan's vaccination team— also dressed in the turquoise "No Polio" T-shirts that seven thousand vaccinators were sporting across the country that day. When we reached the bank, our team helped load the vaccine into the rival clan's trucks. That clan drove the vaccine to their villages and our team got back in the ferry to return to "their" side. But before that, everyone joined together for lunch—a picnic of papaya and watermelons, split by the guards with their machetes.

Such gestures—small moments of peace for polio eradication—were repeated all over Somalia during the three days of the campaign. At its end, 1,400,000 Somali children had been vaccinated against polio.

As we flew back on a perfectly clear day, I looked out the window down at Merka—a beautiful medieval Arab town nestled in a cove on the brilliant Somali coastline. We weren't allowed to land there, as people were known to shoot down planes that tried. It was a shame, as we all wanted to meet a man who lived there, Ali Ma'ow Maalim. In 1977, Ali was the last person on the planet to contract smallpox—the only disease to date that has been eradicated. As we flew over his town, Ali was working as a social mobilizer, encouraging his community to eradicate polio.

I did meet Ali months later, at a meeting in Nairobi. "We were the last country in the world to eliminate smallpox," he said. "We'll be damned if we're the last country to have polio."

By Christine McNab

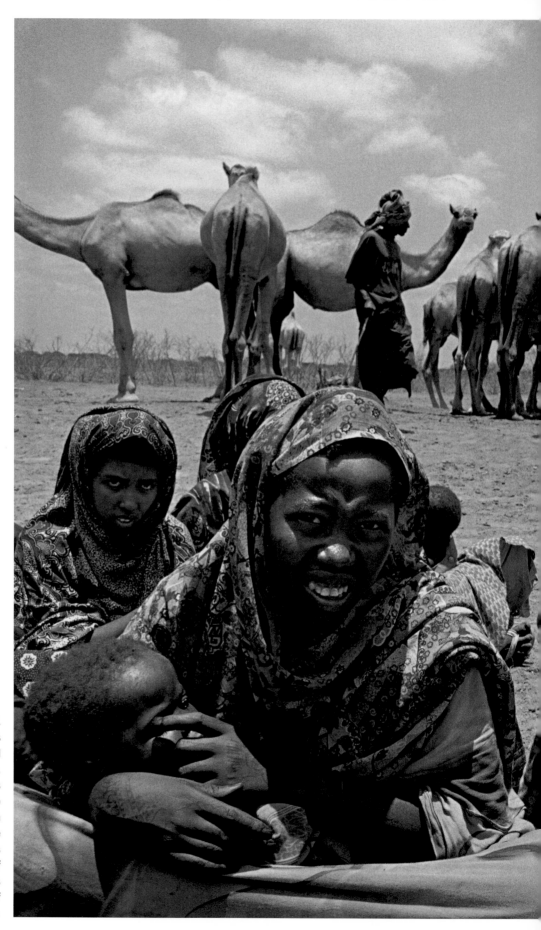

SOMALIA, 2001
Children of nomads
are vaccinated
near the Juba River,
where their families
have come to
collect water. It is a
priority to immunize
all nomadic groups
because their way of
life facilitates
transmission of
the poliovirus.

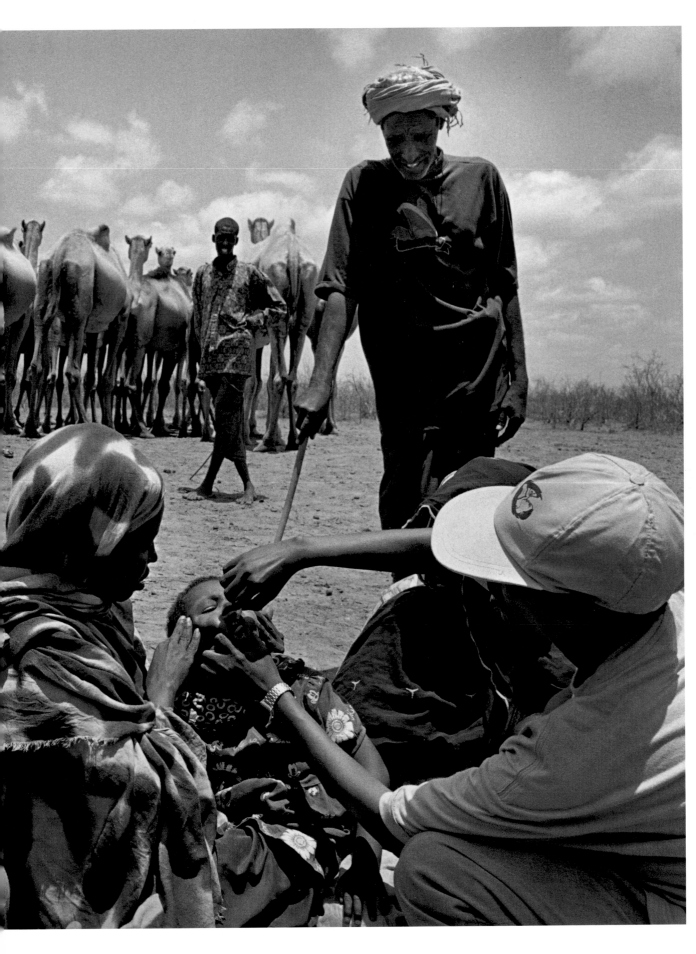

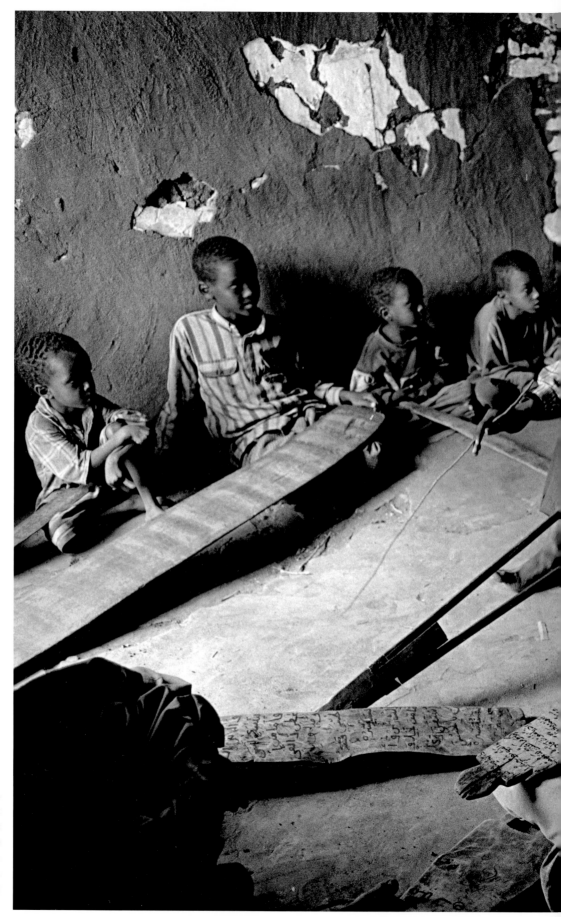

SOMALIA, 2001
A polio-disabled man teaches at the Koranic school in the village of Jamame. Somalia had seven new cases of polio in 2001 and only three in 2002.

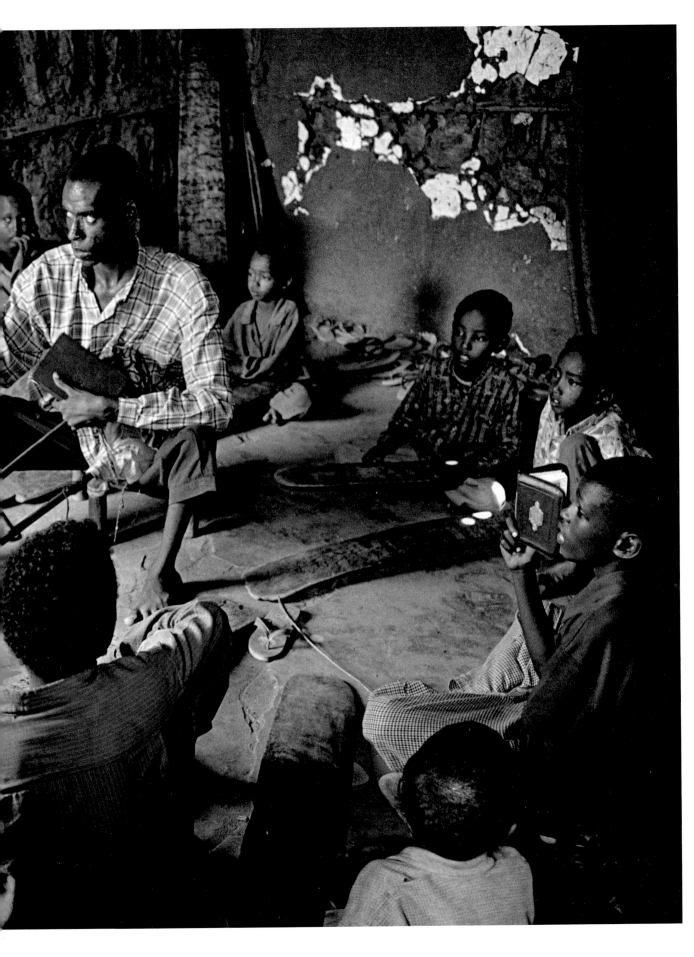

SOMALIA, 2001
Mohammad Aden Ali,
11, paralyzed by polio,
crawls on his hands
and knees in the
Baidoa stadium, where
spectators have come
to watch a football
match between the
teams Polio 2000 and
Polio 2001. The match
is one of a variety of
activities used by
immunizers to gain
support for the eradi-
cation campaign in
Baidoa, which was
stricken by famine in
the 1990s.

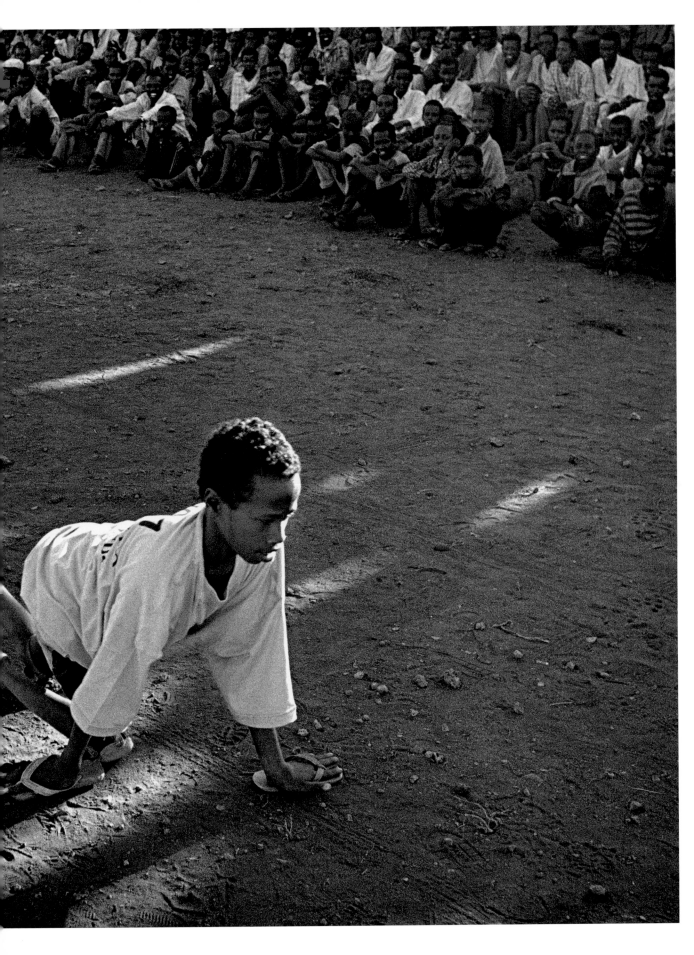

INDIA

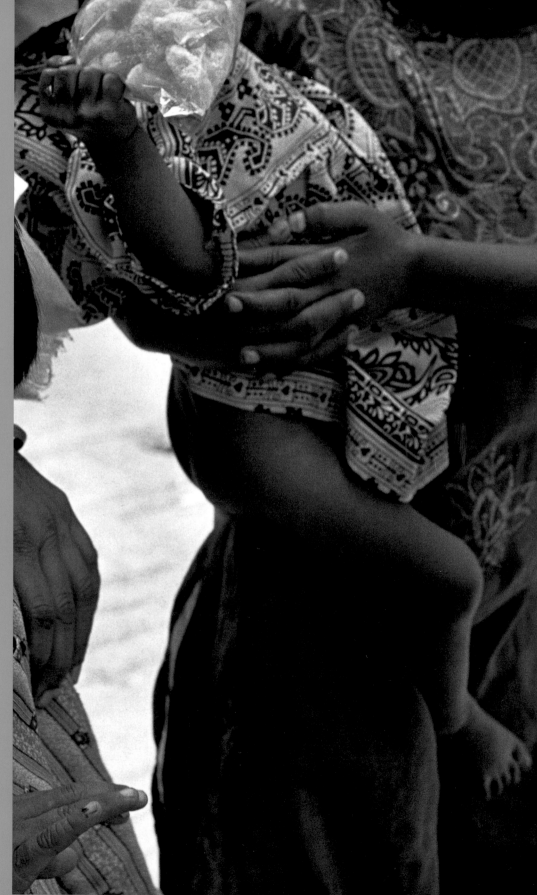

INDIA, 2001
During a round of
National Immunization
Days in Ghaziabad,
Uttar Pradesh, a
volunteer paints a girl's
fingernail with gentian
violet to indicate
that she has received
her polio vaccination.
Several districts here
and in the neighboring
state of Bihar are called
polio "hot zones"
because of continuing
high-intensity trans-
mission of the virus.

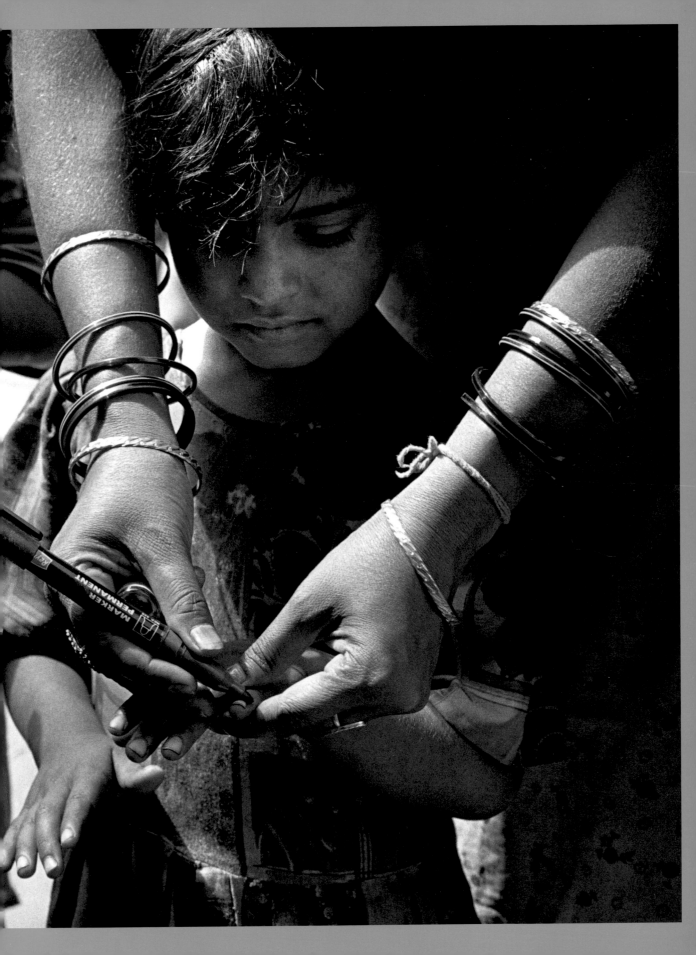

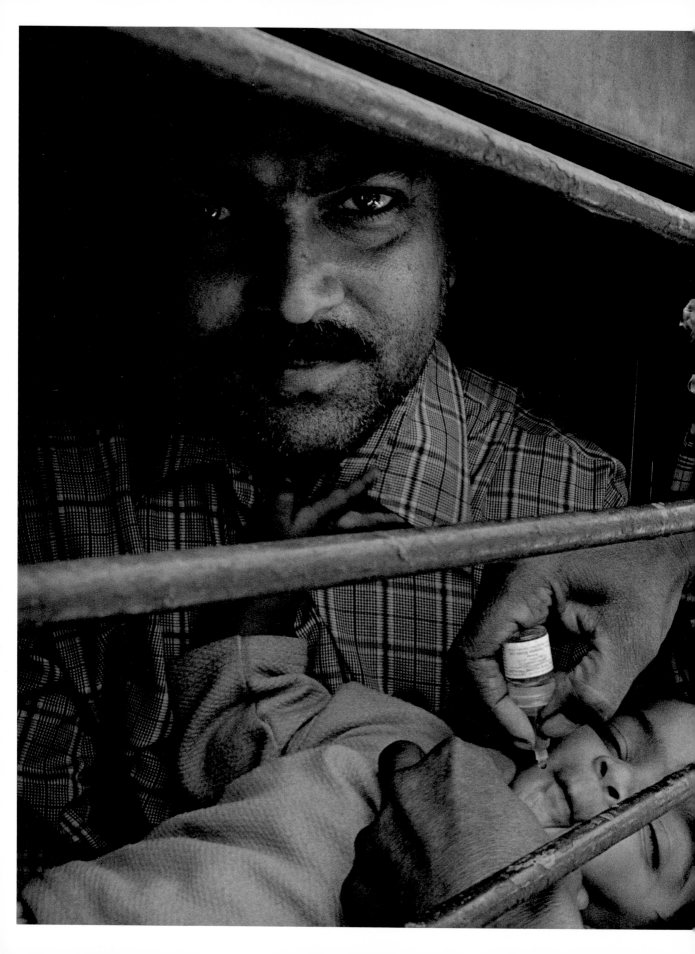

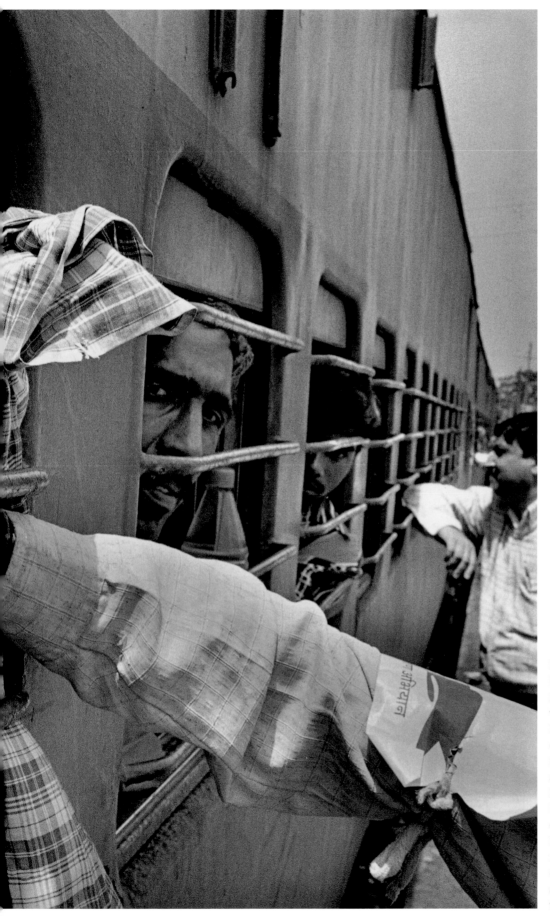

INDIA, 2001
During National Immunization Days in the town of Moradabad in Uttar Pradesh, trains cannot leave the railway station until all children on board have been vaccinated. In 2002, Uttar Pradesh experienced an outbreak of more than 1,000 new polio cases—66 percent of all the new cases in the world that year.

INDIA, 2001
Chhatta Gram Panchayat,
a semi-rural area of
Kolkata, holds a street
rally about the polio
immunization campaign.

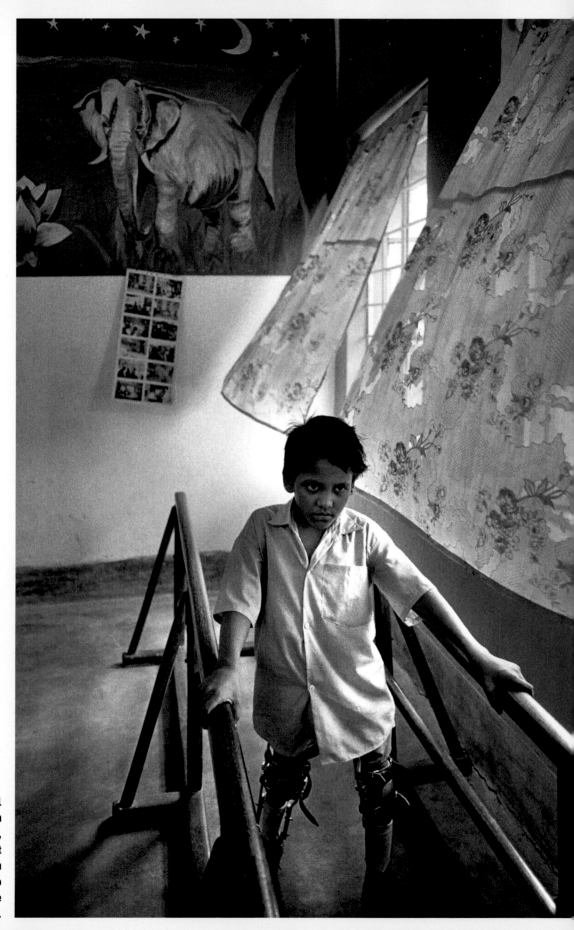

INDIA, 2001
The Rehabilitation
Center for Children,
in Kolkata, West
Bengal, was founded in
1973 primarily to
care for post-operative
polio patients.

STALKING A VIRUS HOUSE-BY-HOUSE

Kolkata, India, October 2001— India's mass polio immunization campaigns combine precision planning, enormous numbers of volunteers, recent scientific advances, ingenuity, and lots of gaiety and spectacle. In the Manicktola slum in Kolkata (formerly Calcutta), as everywhere across the city, the festivities announcing a major polio immunization day begin a week in advance.

The goals of the festivity: all parents must be notified of the upcoming polio immunization day; they must be made aware that every child under age five is to be immunized against polio, irrespective of how many times they have been given the vaccine before; they need to know where immunization centers will be located, and that Rotary and other private organizations have arranged buses or other transportation to help them get there; they must also be advised that on a specified day, teams of vaccinators will visit each and every house to immunize children who were not taken to immunization centers.

To that end, volunteers paste up an array of colorful posters illustrating polio immunization, and bearing slogans in Bengali. Loudspeakers blare the news. The local band marches along the road above the slum, the music and commotion drawing parents and children. Street theater troupes arrive, enacting the suffering caused by polio paralysis and the ease of preventing it. A dozen or so young children no older than ten, trained by a local group of workers, run from shack to shack, self-importantly telling whichever adult they find at home that it is time to have their children immunized.

These noisy scenes are repeated throughout Kolkata. They are repeated in Delhi, in Mumbai, in Bangalore. They take place in the towns of Uttar Pradesh and Bihar, two northern states where polio remains most intensely concentrated. In fact, National Immunization Days stir up such celebratory pandemonium all across India that, to the uninformed, it would seem that preparations for a major traditional festival are underway. The Prime Minister appears on television several times each day, squeezing drops of oral polio vaccine, OPV, into the mouth of a plump infant. Not to be outdone, the chief ministers of every state make their own television appearances, as do film, pop, and sports stars. Incredibly, a horrific health problem has been transformed into an exciting national cause that everybody wants to be a part of.

Behind the scenes, tens of thousands of state- and local-level bureaucrats, health officials and field staff, and volunteers from Rotary and other non-governmental groups work at fever pitch to ensure that the immunization days are a suc-

cess. They have already spent months preparing for this gargantuan production (the dates were set half a year in advance), which requires reaching, in just three days, all of India's nearly 150 million children under the age of five. Every detail has to be covered, right down to mapping localities in microcosm so that not a single child is missed in the house-to-house visits. Any failures in these make-or-break final weeks of preparation will leave a chink in the armor of immunization, putting at risk months of painstaking work and enormous amounts of funds.

The most intense focus has been on ensuring that adequate supplies of OPV are in place across India—without any break in the cold chain that is needed to keep OPV potent. For each national campaign, 240 million doses of OPV are required. For the mass campaigns, the liquid OPV is packaged in two-inch-long, cylindrical plastic vials, each containing enough vaccine for 20 children.

Because each vial has a temperature monitor—a specially treated square on the label turns dark if exposed to heat—vaccinators can readily know, with certainty, if an OPV vial is spoiled. This simple but revolutionary monitor was developed in 1996 through a public-private partnership involving UN and government agencies and corporations in the U.S. and the U.K. Until then, vaccinators had no way of knowing whether OPV was potent or not. Half the OPV used in routine immunization was thrown away at the end of the day because of the risk that it had been damaged by heat. The "vaccine vial monitor" has reduced vaccine wastage by about 25 percent, saving an estimated $20 million a year on vaccine purchases.

About a month before the campaign, these millions of vials make their way to state- and district-level vaccine storage centers, throughout India, in large insulated cold boxes ferried by planes, trains, and trucks. In these centers, they are stored in deep freezers. A week before the campaign begins, the vials are distributed to the countless immunization teams in vaccine carrier boxes—made of a light, insulated foam to trap in cold—that can easily be carried by a single adult. Innumerable ice packs, which keep the vaccine carrier boxes chilled, are also distributed to the vaccination teams.

Just before ten o'clock on Sunday morning, the day the immunization campaigns typically begin, three three-person teams, ferried in a car lent by a generous Rotarian, arrive in the Sonagachi neighborhood of Kolkata, an area home to some of the city's most famous brothels and long shunned by health-care workers. Each team bears a white vaccine carrier and the vaccinators all wear bright yellow waistcoats with "Polio Plus: Stop Polio!" emblazoned in both Bengali and English.

One team sets up at a private health clinic, where a few parents are already waiting to have their children immunized. The other teams move out on foot into different sections of Sonagachi. By the time they knock at the door of the first house, they have attracted an escort of noisy, rag-tag kids. Some of the kids are carrying younger siblings who are promptly immunized by the vaccinators. Their

heads are pushed back, mouths prodded open, and two drops of pink OPV liquid are squeezed from the vial. The older siblings are instructed to tell their parents that their charges have been immunized.

The teams go door-to-door, speaking to anyone who appears, asking whether there are children there under the age of five. From the brothels and homes alike, mothers, grandmothers, friends, and sometimes fathers, bring their infants and young children. Often, if little ones aren't brought out quickly enough, vaccinators push into the dark, warren-like houses, searching for the children.

House after house is marked with signs in chalk. A large "X" signals that some children in the home were not vaccinated or that the vaccinators expected children to be present and they were not. A "P" means that every child was vaccinated, or that there are no children under the age of five.

Soon, the houses have all been visited, and the workers begin systematically searching alley after alley. By late afternoon, between the hundreds of children immunized at the local health center and those covered in the house-to-house rounds, every single child in Sonagachi under the age of five has been given two drops of OPV.

In much the same way, every child younger than five in Kolkata has received his or her two drops of OPV, a process replicated all across India. A month or so later, this national effort will be repeated yet again.

These gigantic mobilizations, which occur year after year and are comple-mented by strengthened routine immunization services, have reduced annual polio cases in India 99 percent from 1988 when the global eradication effort began. Elim-inating the last cases—estimated at 1,550 in 2002, which constitutes 85 percent of the global total—is expected to be the greatest challenge of all. While the resur-gence is predominantly in Uttar Pradesh and Bihar, even the city of Kolkata, which had been polio-free for almost two full years, experienced three new cases in 2002. These outbreaks have demanded an even greater deployment of vaccines, planners, health workers, and volunteers, and a substantial additional commitment of national and international funds. The next few years will tell if this all-out effort to protect every single Indian child under five from this disease will finally succeed.

By Siddharth Dube

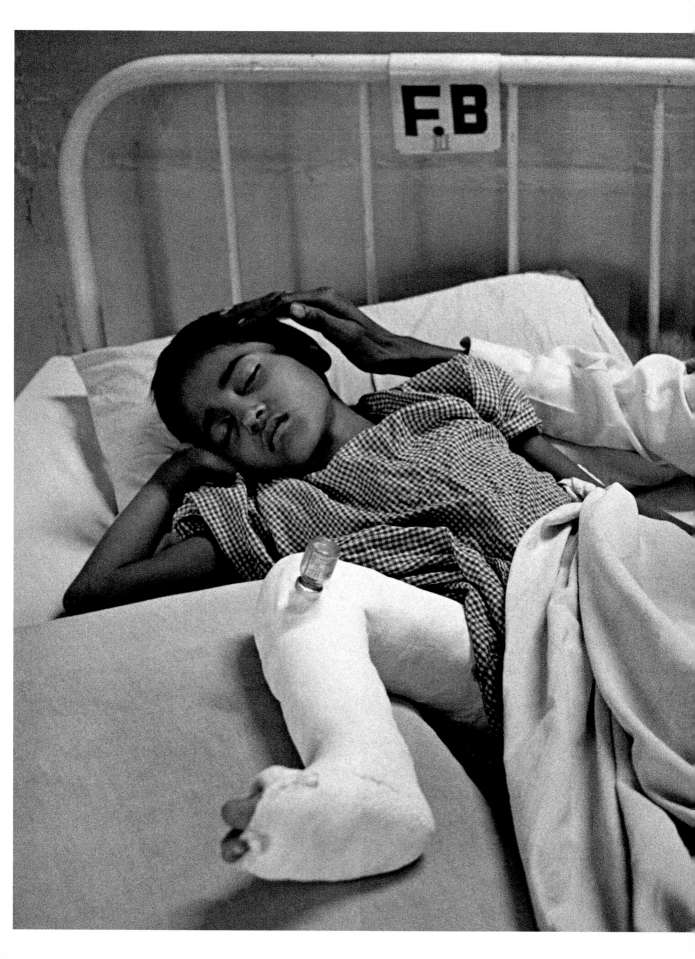

INDIA, 2001
In a New Delhi hospital, a father comforts his daughter: she is recovering from corrective surgery on her right leg, which was paralyzed by polio. Many doctors donate their services to paralyzed children for free.

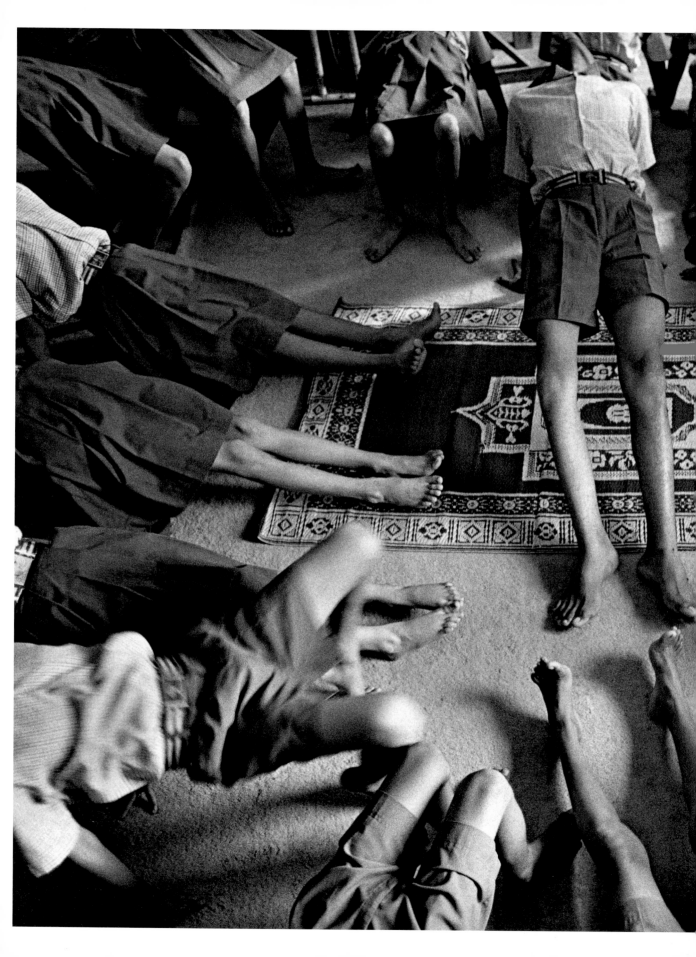

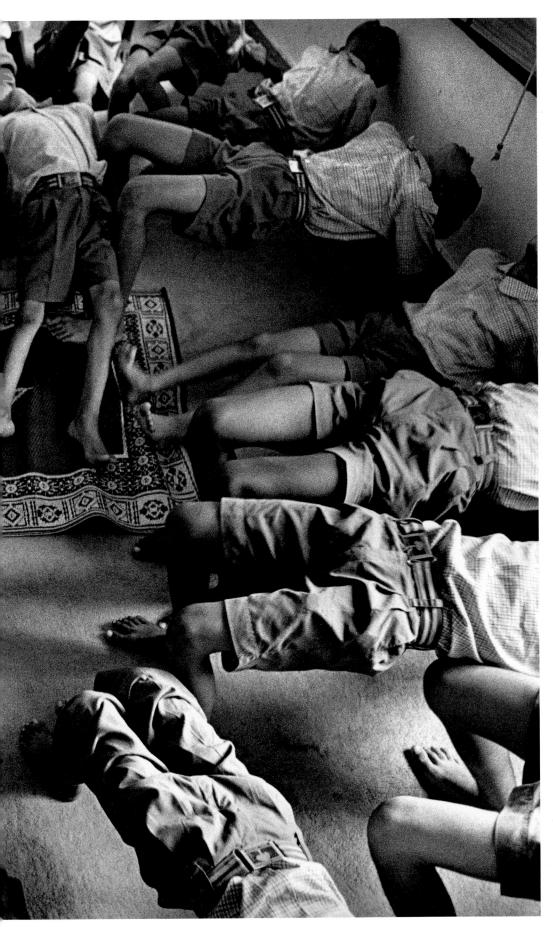

INDIA, 2001
At the Akshay
Pratishthan Institute
in New Delhi, children
participate in a yoga
class that helps
stretch their limbs
and improve mobility.

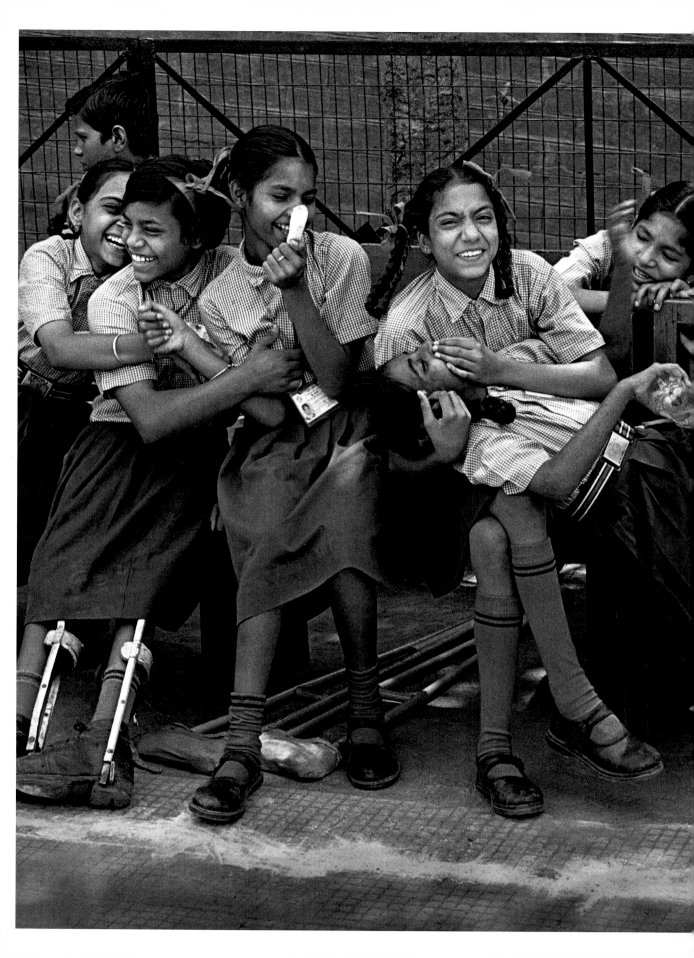

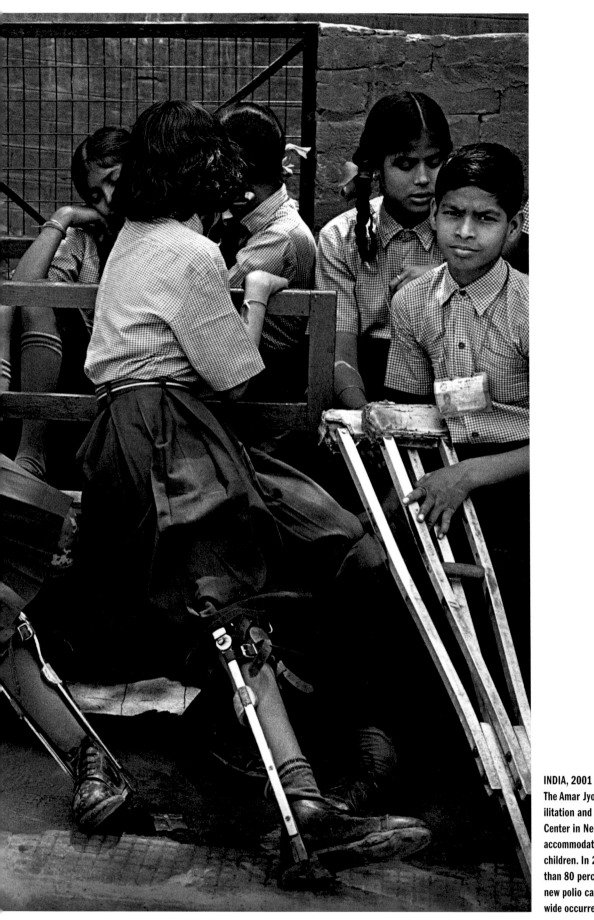

INDIA, 2001
The Amar Jyoti Rehab-
ilitation and Research
Center in New Delhi
accommodates 540
children. In 2002, more
than 80 percent of all
new polio cases world-
wide occurred in India.

(continued from page 21)

A GARGANTUAN JIGSAW PUZZLE

In mid-October 2001, precisely 40 years and one month from the day my brother, Pratap, was paralyzed and I was born, I am back in Kolkata (formerly Calcutta). Miraculously, there had not been a single case of polio in the past two years.

The slums and destitute squatter colonies I visit are littered with garbage and other muck. The sewers, where there are any, are open drains. In the monsoon's second phase, the drains quickly flood and filthy water accumulates everywhere. There are flies and uncovered food aplenty. As there are few or no toilets, most children and adults simply defecate on the sides of roads and pathways. But despite all this, everything that spreads polio in poorer countries, there was no polio.

I felt the beginnings of joy and amazement. How can it be, that just wing-beats from the affluent area where Pratap and I lived as children and where he contracted polio, there were no more outbreaks of this once omnipresent disease? How can it be that even in the most desperately poor localities, despite the pervasive filth, inadequate sanitation, and the virtual absence of doctors and health care facilities, polio had been stopped?

The miracle, for this is certainly what it is, even by rational standards, is the work of a global effort toward immunization to eradicate polio, launched in 1988 and now thrillingly near its goal. Eradicate! Not to reduce, not to minimize, not to contain, but to eradicate polio forever. To ensure that not one more person suffers what Pratap and Brij Lal—and tens of millions of other children and adults in the past century alone—have suffered.

I always imagine the polio eradication effort to be a gargantuan jigsaw puzzle—a puzzle spanning the earth and every one of its six billion-plus people—that has been painstakingly pieced together by legions of passionately committed people, all part of a collective public health effort unequalled in scope in the history of the world. These jig-saw puzzle pieces include raising billions of dollars for the eradication effort. Persuading presidents, Nobel laureates, and sports heroes to lead this effort. Coaxing warring armies into ceasefires to allow immunization. Getting pharmaceutical companies to multiply their production of the polio vaccine. Building a movement of millions of volunteers who, to ensure that vaccines get to where children live, have forded flooded rivers, crossed deserts on foot and jungles on elephants, and braved wars.

The worldwide eradication effort formally began in May 1988, when the health ministers of nearly every country on the planet gathered at the headquarters of the World Health Organization in Geneva for their annual meeting, the World Health Assembly. Out of this assembly came a truly momentous declaration, a unified commitment to eradicate polio by the year 2000. (This was the year set for ending transmission: three to five years without any polio cases anywhere in the world are needed to certify eradication, hence the target date of 2005.) In the words of their resolution, the eradication of polio was to be

"an appropriate gift, together with the eradication of smallpox, from the twentieth to the twenty-first century." The attending ministers—166 in all—unanimously adopted the resolution amidst the kind of excitement rarely displayed by this august body.

The eradication of smallpox, in October 1979, had proved that a heroic effort, over a span of 12 years and more than 30 countries, could indeed achieve the Herculean task of wiping out a deadly and highly contagious human disease. Until that campaign was launched, the annual death toll from smallpox was over two million people, with millions more left disfigured and sometimes blinded. To conquer it was as unimaginable as landing humans on the moon had once seemed. The elimination of poliomyelitis became the next objective, "the target disease most amenable to global eradication," as the World Health Assembly resolution noted.

Smallpox and polio were the first targets for eradication because they were among the most threatening of a very small group of diseases with the specific biological characteristics that make them susceptible to eradication. To begin with, the disease-causing organism must be one that cannot survive or breed in animals, insects, or, for more than a short time, in the environment. Humans must be the organism's only potential host, and it must be impossible for humans to carry it long term. With these criteria present, human ingenuity must create vaccines that are safe, effective, and potent enough to provide lifelong immunity against the disease. With the development in the 1950s of two powerful anti-polio vaccines—the Salk injectable vaccine and the Sabin oral vaccine—the potential now existed that, once deprived of its human host, wild poliovirus would die out.

But making that leap—from theoretical possibility to actually eradicating a disease as omnipresent as polio—was a massive and complicated task that, to many, seemed impossible. Though less deadly than smallpox, polio was both more ubiquitous and elusive an enemy. Polio spreads so easily and fast that, without immunization, almost everyone living in regions with poor sanitation would be infected by it, typically in childhood or otherwise as adults. Even in 1988, when the eradication effort began, polio was endemic to 125 countries—over four times the number of countries that smallpox was endemic to at the launch of that eradication effort.

Waging war on the poliovirus presents several other formidable challenges that were not encountered in the campaign against smallpox. Consequently, the eradication of polio has called for an effort many times larger, more complex, and more expensive. Some of the obstacles that have had to be overcome in the fight against polio include:

• Because the overwhelming majority of polio infections are sub-clinical, meaning they produce nothing worse than flu-like symptoms, just 0.5 percent of people who become infected develop paralysis or die, although all infected individuals are conta-

gious for several weeks. Unfortunately, the frequency of symptomless polio infections makes it a far more difficult disease to contain than smallpox, which inflicted ghastly symptoms upon virtually every person it infected. By the time a single case of paralysis strikes, the poliovirus is likely to have spread so widely that the strategy that proved to be the death-knell for smallpox—immediately immunizing everyone in the vicinity of a person who has fallen sick (barring those already immunized or those who had contracted smallpox before)—proves completely ineffective.

• While the smallpox vaccine only needed to be administered once and left behind a distinctive scar, immunity to polio requires that four doses of the vaccine be administered several months apart. Furthermore, polio vaccines leave no visible marks, which adds to the logistical difficulties of administering an effective immunization program, as it is impossible to determine, without a blood test or dependable individual records, whether a person has received any or all of the four doses of the vaccine needed for lifelong immunity.

• To stop polio's spread, each and every one of the world's 600 million children under the age of five—including over 130 million newborns each year—has had to be fully immunized against the virus. At the outset of the global eradication effort in the late 1980s, only 60 percent of children in that age group were being fully immunized. Consequently, at that time over 350,000 unprotected children were paralyzed by polio each year—almost 1,000 every day.

• With immunization levels so poor, polio persisted in five continents, most severely in Asia and Africa. The heaviest burden of polio was in the most impoverished countries, in those torn by conflict, and in those that had failed to invest in immunization even though they could afford it. It was crucial that every country cooperate in the eradication effort, as the persistence of polio anywhere on the planet would mean a continued risk for all. How would it be feasible to deliver immunization programs to the children of impoverished families, when the vast majority of them rarely, if ever, had access to any health services? In the many countries shattered by unending civil war or other armed conflicts, how could immunization workers safely reach the people, to ensure that each and every child under the age of five would be inoculated?

• And, how would it be possible to persuade the governments of impoverished countries, burdened as they already were with so many incalculably harsh problems, to commit a portion of their scarce resources and energy to a campaign against a single disease? Poor and rich countries alike have had to summon up and devote substantial sums to implementing the eradication effort. Some low-income coun-

tries, like China, have themselves met virtually all of the costs involved. Even the very poorest countries have often covered half of the costs of their national efforts. Rich-country individuals, foundations, non-governmental organizations, and governments will have together raised more than three billion dollars for the global effort by 2005.

• The production of the oral polio vaccine (OPV), the vaccine of choice for the eradication effort—reliable, cheap, painlessly and easily administered—has had to be multiplied, despite the shrinking number of OPV manufacturers. Since 1999, when an increasing number of countries began mass vaccination campaigns against polio, nearly three billion doses of OPV have been needed each year, more than three times the amount used earlier.

• Because OPV is susceptible to heat spoilage, it must be stored and transported under constant refrigeration (at a temperature as close as possible to minus twenty degrees centigrade) in a system known as a "cold chain." Cold chains are essential, but an enormous challenge in countries that, even in their capital cities, often lack stable power supplies, are without electricity or power sources in most rural areas, and have few refrigerators.

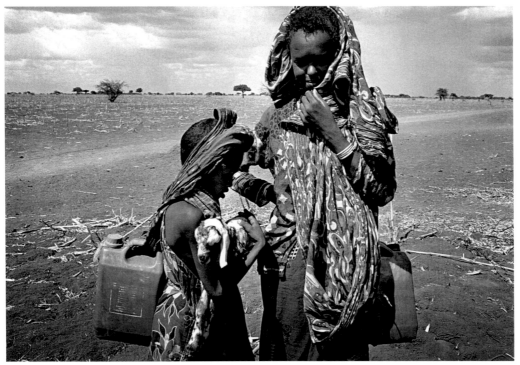

SOMALIA, 2001. A nomad mother and child near Baidoa.

In spite of these and other daunting obstacles, 15 years later, a worldwide campaign has almost completely accomplished each and every one of these seemingly insurmountable tasks. Five million children, almost all in developing countries, who would otherwise have been paralyzed by polio, are walking because they were immunized against this disease. The lives of another million children have been saved and many millions more protected from blindness because, during polio immunization campaigns, they received vitamin A supplements that are vital to boosting overall immunity against disease and preventing blindness from vitamin A deficiency. Countless other children have been saved from death or severe illness because coverage rates with other vaccines have risen as the polio eradication effort has rallied political support, finances, and public demand for disease immunization in general.

REACHING 600 MILLION CHILDREN

The campaign against polio owes its success thus far to a combination of human idealism and commitment—political will. Stoking this political will among the world's decision-makers, those who decide how money and manpower are committed to development programs, is a mission led by two organizations, each with a history of remarkable humanitarian achievements, the World Health Organization (WHO) and the United

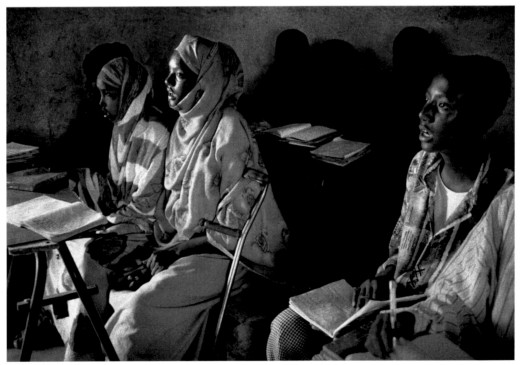

SOMALIA, 2001. A young girl with polio in a classroom in the village of Jamame.

Nations Children's Fund (UNICEF). WHO is the United Nations agency mandated to help all people—especially poor and vulnerable populations—attain the best possible level of health, and brings to this effort unrivalled policy and technical skills. UNICEF, with a strong presence and broad partnerships across 162 countries, works to ensure health, education, equality, and protection for every child, so that each can reach his or her fullest potential. They have long worked in tandem on tackling the health and nutrition problems that beset the world's children.

The job of rallying the necessary political support for a polio eradication plan has been made much easier for these two organizations by virtue of their track records of establishing programs around the world that, despite overwhelming odds, have proven extremely successful. Fresh in the minds of decision-makers was the effort led by WHO, with the support of UNICEF and a panoply of other groups, that resulted in the triumph over smallpox. As a result, despite the awesome magnitude of the task of eradicating polio, leaders everywhere believed it was doable, mainly because WHO and UNICEF said that it was.

Apart from the eradication of smallpox, UNICEF, in alliance with WHO, had been at the vanguard of another extraordinary humanitarian movement, launched in 1982 and called the Child Survival Revolution. At the beginning of the 1980s, throughout the world, 15 million children under the age of five were dying every year, mostly from preventable causes. Within a decade, the Child Survival Revolution was saving the lives of three million children annually. At the core of this agenda were massive worldwide efforts to popularize practicable, cost-effective, life-saving measures against preventable illnesses and deaths.

One important element of the Child Survival Revolution was teaching mothers about the value of breastfeeding (over expensive and much-advertised formula) as a means of optimizing nutrition and providing immunity to diseases in an infant's first year of life. Other health services were implemented to monitor the growth of infants and very young children, to check for telltale signs of malnutrition or illness, and to provide inexpensive oral re-hydration treatments against childhood diarrhea, all too common in areas with poor sanitation.

But, unquestionably, the cornerstone of the Child Survival Revolution was the immunization of young children against diseases. In 1981, before the launch of this campaign, in most poor and low-income countries only 10 to 20 percent of children were fully immunized against the six main vaccine-preventable diseases: polio, diphtheria, whooping cough, tetanus, measles, and tuberculosis. By 1990, the number of children fully immunized against these diseases in the first year of life had climbed to about 80 percent, with the happy result that, annually, over a million deaths from measles, neonatal tetanus, and whooping cough—as well as almost 200,000 cases of polio paralysis—were being prevented. Decision-makers in every corner of the world noted that immunization was

the only modern medical breakthrough that had been made available, not to 10 percent or 20 percent of the world's people, but to the vast majority. They were left convinced that vaccines were "magic bullets" and "miracles of prevention."

Immunization against childhood diseases proved to be the outstanding public health success story of the 1980s, on par with the eradication of smallpox a decade earlier. The indisputable fact was that even in the harsh "lost development decade" of the 1980s, with Africa and Latin America devastated by adversities ranging from spiraling debt to the onset of AIDS, immunization brought about significant improvements in the quality of life for everyone. It became clear to leaders everywhere that immunization was a public health bargain like no other.

Equally impressive was the ability of these immunization campaigns to extend to tens of millions of people never before reached by other health services—the very poor and disenfranchised, the people living on the streets or in remote villages, those trapped in conflict. In countries as diverse as Colombia, Burkina Faso, Senegal, Nigeria, Turkey, and India, organizations such as UNICEF and WHO, and other partners helped transform immunization goals into a society-wide crusade in which nearly everyone played a role—heads of state, politicians, the religious establishment, the armed forces, teachers, Boy and Girl Scouts. Rates of child immunization skyrocketed, even among families who had never previously been treated by a healthcare professional.

The demonstrated feasibility of mobilizing such broadly successful immunization campaigns gave the polio-eradication proposal tremendous credibility among the world's decision-makers. This case was made more compelling with evidence from the Americas and other industrialized countries that it was indeed possible to completely eradicate polio.

Cuba had shown the way, decades earlier. By 1962, this island country had entirely freed itself of polio—the first to achieve this—through mass immunization using the oral vaccine that had been invented just half a decade earlier by the U.S. scientist Dr. Albert Sabin. Simultaneously, industrialized countries were curbing the devastating summertime polio epidemics that had swept these nations since the turn of the century, paralyzing and killing large numbers of children, teenagers, and young adults. In contrast to the pattern of polio infection striking mostly young children in poorer countries, teenagers and adults were the most severely affected groups in industrialized nations. Ironically this was in part because vast improvements in sanitation at the beginning of the twentieth century had sharply reduced their exposure to wild poliovirus in early childhood, thus preventing them from developing natural immunity.

In 1955, at a time when nearly 20,000 Americans were paralyzed annually, the first polio immunization campaigns were undertaken in the United States, using the injectable vaccine invented the previous year by Dr. Jonas Salk. Within only two years, the number

of paralytic polio cases in the United States had fallen by 80 percent. In 1961, the United States replaced the Salk vaccine with the more easily administered Sabin oral vaccine. By 1967, the number of annual new cases of paralytic polio in the United States had dropped to just 40, and 12 years later the country was completely free of polio. By 1993, every industrialized country in the world had rid itself of polio, with no more cases of indigenous transmission. (A dwindling number of "imported" cases, where children are infected from polioviruses that come from abroad, persist.)

The defeat of polio in Cuba and the United States by the late 1970s encouraged mass polio immunization campaigns in the rest of Latin America and the Caribbean. Brazil, the largest country in the region, began to invest in these mass campaigns in 1980—and, in just three years, had virtually ended polio within its borders. Brazil's success was of epochal importance. Possibly more than any other factor, it led the health ministers of Latin America's thirty-seven countries, in 1985, to resolve at their annual meeting at the Pan American Health Organization (the regional branch of the World Health Organization) to eradicate polio in all of the Americas. This goal was achieved. In 1994, the Americas became the first region in the world to be certified polio-free.

But, polio can only be vanquished if every country agrees to do their part. To make the gains in their own countries permanent, the health ministers from industrialized

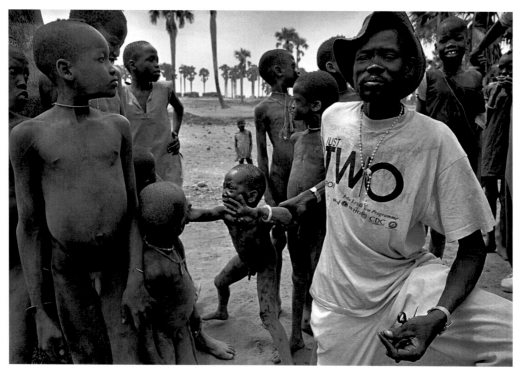

SUDAN, 2001. Polio vaccination at the cattle camp of Wumpul, in the Maper Payem area of the Rumbek district.

115

countries, Latin America and the Caribbean needed to persuade all their counterparts in the 125 countries where polio was still endemic, that its eradication should be a shared top priority.

Ultimately, creating the political will for global polio eradication is, and remains, a matter of moral suasion. The unanimous passage, in 1988, of the World Health Assembly resolution to eradicate the disease was *the* critical turning point. Just two years later, at the 1990 World Summit for Children at United Nations headquarters in New York, the assembled heads of state re-enforced this decision, committing themselves to achieving a range of goals relating to children's survival and development, chief among which was the eradication of polio.

Securing political will was only the first of many hurdles to realizing polio's eradication. The greatest challenge has been logistical: actually vaccinating against polio every young child in the world—90 percent of whom are born in developing countries. This staggering task has required getting the oral polio vaccine safely from the handful of companies that manufacture it, to the mouth of every single young child at least four times before their fifth birthday.

Here, Rotary International, an influential international association of business and professional people committed to volunteer service, has been of immense help. In 1985, Rotary adopted the goal of immunizing all of the world's children against polio by the organization's centennial anniversary in 2005. By that date, the Rotary will have raised more than $500 million to help eradicate the disease—the largest single private sector contribution ever made to a public health program. Rotary's 1,200,000 members have also taken on the practical and indispensable job of motivating communities, lending their vehicles to deliver vaccines, hauling equipment, serving lunches, and administering the polio drops to children.

Similarly, the U.S. Centers for Disease Control and Prevention (CDC), the fourth spearheading partner of the global effort to eradicate polio (along with WHO, UNICEF, and Rotary International), has aided the campaign since 1985 with projected expenditures of almost $800 million through 2005. Its most important unique contribution has been as a "viral detective," using its expertise in virological surveillance—or genetic fingerprinting—to identify the strain of poliovirus in an outbreak to determine its origin. This is vital to better target immunization efforts. The surveillance system is also key to determining when each country, and eventually the globe, can be certified polio-free.

As I complete this essay in January 2003, poliovirus persists in only seven countries, down from 125 in 1988. (The number of new cases of children paralyzed by the disease worldwide annually has dropped to under 2,000, a more than 99 percent decrease from the estimated 350,000 cases in 1988.) Doing away with polio in these 118 countries was by no means easy. Many of them, like Bangladesh, China, and Indonesia, are vast, densely

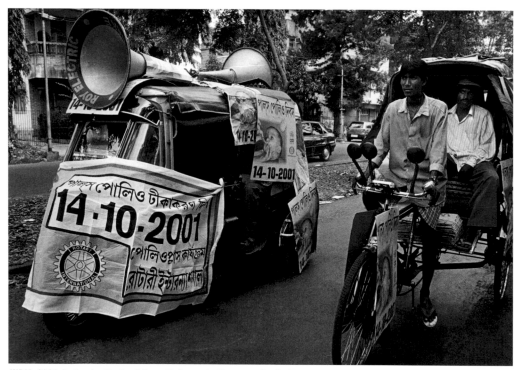

INDIA, 2001. A street rally about the polio immunization campaign in Chhatta Gram Panchayat, a semi-rural Muslim area of Kolkata. Seven hundred public school children attended the rally, which was organized by the Women's Interlink Foundation.

populated, and poor. Yet vanquishing the poliovirus within its last seven outposts, all in Africa and south Asia, will probably be the most demanding phase of the eradication effort. Although cornered, the disease now hides in some of the most destitute, poorly-governed or strife-torn parts of our world.

The final stages of any great endeavor are often when the risks are greatest, and the stakes highest. A failure at this stage could undo many of the hard-won advances made by the immunization programs to date. As long as polio persists, even in just a few countries, the world's 190-odd polio-free countries must guard against an importation of wild poliovirus that could set off a recurrence of infection within their own borders.

A drop in immunization coverage rates also makes countries vulnerable to the very remote chance that the weakened virus in oral polio vaccines may have a chance to circulate, and eventually become virulent, causing disease. There have been four documented instances of this occurring and causing several cases of paralysis. All four vaccine-caused outbreaks were controlled by immediately vaccinating the surrounding child population. However, in comparison to the tens of billions of doses of OPV successfully given children over the last 40 years, it is clear that the overwhelming benefits of this vaccine far outweigh its rare risks.

Other risks associated with decreased immunization coverage are that the virus could escape from laboratories or vaccine manufacturing plants, or that it could survive for possibly decades in immune-deficient people. As the elimination of wild poliovirus draws closer, these issues are acquiring more urgency. Measures to secure containment of remaining live virus, ongoing high-quality surveillance and alternative options to OPV are all under discussion as the world approaches the certification of polio eradication.

There is, however, a virtual consensus that there is no choice but to continue high rates of global immunization against polio for the foreseeable future. This will become an increasingly difficult proposition as memory of the toll exacted by polio dims in the public mind, and a host of other severe diseases compete for government and donor funds. In the end, financial shortfalls, lengthy delays in the distribution of vaccine, or failure to vaccinate every child in every one of these last outposts could conceivably doom the effort to achieve global eradication.

INDIA: THE GREATEST CHALLENGE

To this day, India remains the most significant breeding ground of poliovirus. As is true elsewhere, the virus is concentrated in the poorest, most disadvantaged communities.

By the mid-1960s, children of upper- and middle-income Indian families were routinely vaccinated against polio. My brother Pratap was among the last few children of well-off Indian families to contract the disease. With the immunization of the country's more affluent children, polio soon became yet another perennial affliction of the impoverished majority.

In 1988 and 1989, when the global eradication effort was being launched, I wrote several investigative articles about polio in India. I saw nothing then to give me the slightest hope that it would ever be defeated. Our national immunization programs for all diseases were completely inadequate. Consequently, as many as three million young children were killed or disabled every year, mostly by diseases that could have been prevented through inexpensive vaccinations. Likewise, the government's polio immunization program had ground to a bureaucratic standstill, with the federal Ministry of Health wanting to use the oral vaccine and the Ministry of Biotechnology insisting on changing over to injected vaccine. Two hundred thousand children were being paralyzed by polio annually, and for several thousand the disease was fatal.

Yet, today in India, despite critical remaining challenges, transmission of this dread disease is on the verge of being ended. The year 2001 saw the lowest annual number of new cases ever: only 268. In 2002, the number of cases surged again. At this writing, they are estimated at more than 1,500, concentrated in the northern states of Uttar Pradesh and Bihar—two of India's poorest states—but also found in other parts of the country

that have had no new cases for one, or even two years. Explanations for this setback include: insufficient commitment due to outright discrimination (most of the unreached are Muslim) or bureaucratic apathy, loopholes in coverage strategies, or the difficulties overcoming the mistrust of the long-neglected poor. Whatever the causes—and they are as complex as the social fabric in which the poliovirus hides—the total number of new cases is still less than 1 percent of the number paralyzed in 1988.

To appreciate how momentous this is, one only has to consider the obstacles that have been overcome. When, in late 2001, the photographer Sebastião Salgado and I visited the vast "squatter colony" (an illegal slum) adjacent to the Manicktola bridge in the northern part of Kolkata, it had been free of polio since the beginning of the year 2000. (There were three new cases in other parts of the city in 2002.) Conditions in the slum were unimaginably harsh, by far the worst I had seen in twenty years of working in impoverished areas in India.

The entire slum, housing several hundred thousand families, lies right along the banks of a fetid drainage ditch. Once a broad canal, it has shrunk to a stinking, 12-foot-wide channel of black, viscous water indistinguishable from petrol, and choked with excreta and every other type of refuse. The atmosphere on this side of the drain is made even darker and more oppressive by a massive overhead metal

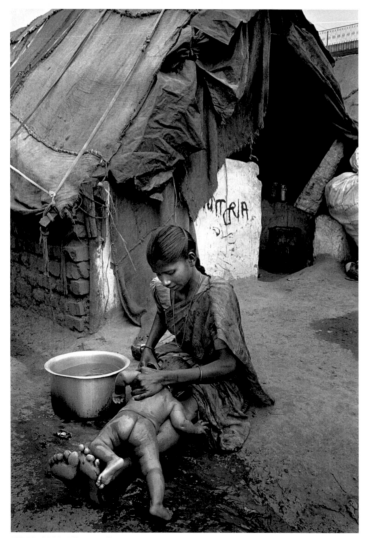

INDIA, 2001. Migrants from southern India, in the Kurula area of Moradabad District. The district has one of the highest numbers of polio cases in India.

119

pipeline, perhaps eight feet wide, that, in an appalling irony, carries clean water to wealthier neighborhoods.

In the shadow of the bridge and pipeline, the air is dank and intensely polluted. Shacks line the bank of the drainage ditch and spread, tightly pressed one against the other, virtually all the way to the busy road above. The narrow spaces between the shacks serve as paths, though none is broad enough for two adults to pass. For that matter, few of the shacks are tall enough to allow an adult to stand up straight. Most are tiny—about a dozen feet in length and width. Yet each houses one or more families, often as many as ten people, inhabiting every inch of the earthen floor and sleeping in rudimentary bunk beds. All these shacks are constructed almost entirely of discarded rubbish—broken bricks, cardboard, torn tarpaulin, plastic sheeting, some bamboo, earth, and thatch. There are scarcely any possessions inside the shacks: some clothes, bedding, a small number of utensils, an old suitcase or trunk, posters of film-stars or gods, perhaps a tiny radio, and in a few "better-off" dwellings, an ancient cassette-player or TV.

Numerous infants and young children live in the slums, and few of them go to school for long. Until they are old enough to work at a trade—usually at age ten or eleven—they care for their younger siblings, do housework, or simply roam the slum. Few have any clothing other than

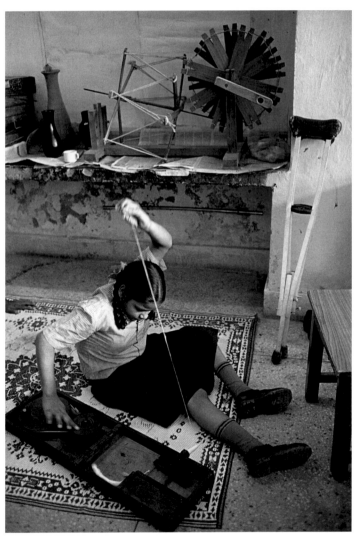

INDIA, 2001. A girl weaves at the Amar Jyoti Rehabilitation and Research Center in New Delhi.

120

rags or underwear. Irrespective of age, many go barefoot, while others wear worn-out rubber slippers that offer no protection from infections, disease, and dangerous debris.

In the Manicktola slum, as in most slums in India, health services are virtually non-existent. The single dingy, under-staffed health sub-center cannot meet the needs of tens of thousands of people. It is only when illnesses become very serious that adults and children join the unending lines at the closest public hospital. No one knows how many children die in the slum or from what causes. The lack of official record-keeping is such that most children have never been issued birth certificates, thus obviating the need for death certificates.

For the health problems that beset them every day, families in the Manicktola slum, like other impoverished Indians, have nowhere to turn but to the legions of unregulated private practitioners, most of them untrained quacks. Despite charging sizeable fees, these opportunistic private practitioners too often cause terrible harm. Their custom of giving injections to "cure" fevers precipitated many cases of polio paralysis across India, until the transmission of polio dwindled in recent years. (In children or adults already infected with polio, intra-muscular injections—and even strenuous activity—actually provoke paralysis or worsen its consequences.) Left alone, the symptoms would probably not progress beyond the fever stage—the usual outcome for all but 0.5 percent of people infected by polio—or would result in a milder form of paralysis. An authoritative report estimates that the practice of injecting to treat fevers caused "provocative" polio or resulted in more severe paralysis in 1,500,000 Indian children between 1980 and 1990 alone.

In northern India, the obstacles are of a different order. Baba ka Gaon, the Uttar Pradesh village where I met Brij Lal, is almost like a second home for me, as I spent nearly two years here in the mid-1990s documenting the memoirs of his uncle's family. Baba ka Gaon is a typical north Indian village—five hours by bus from the nearest city, several kilometers of broken dirt trail between it and any paved road. Its hundred or so families are divided among a few large brick homes in the upper-caste area, and numerous ragged mud huts in the impoverished lower-caste outskirts. As is the norm in much of rural northern India, many of Baba ka Gaon's villagers frequently lack basic necessities—food, shelter, and medicines—while the poorest 10 percent of families live in unremitting destitution.

Such widespread, chronic poverty is by itself enough to jeopardize survival and well-being. But the odds are worsened because medical and other essential services barely function around Baba ka Gaon, in a pattern typical of northern India in villages, towns and cities alike. In theory, a health worker is supposed to visit Baba ka Gaon regularly, mainly to promote children's health, but no one can recall when such a visit last occurred. Taking advantage of the health worker's non-attendance, a pleasant but completely

untrained young man profits from hawking phony medicines, uncalled-for injections, and useless advice.

There is a primary health center relatively close by, but it provides minimal services, little more than treatment for fevers and, occasionally, immunization. There are almost no essential medicines available at the health center, no drugs for tuberculosis or other ubiquitous illnesses, no emergency surgery, and no childbirth facilities. The refrigerator rarely functions; even if it did, there is frequently no electricity for days on end. When they or their children are desperately sick, the poor of Baba ka Gaon pull together what little cash they have to make the daylong journey to the district hospital. But even here they receive only substandard care. The crowded yellow buildings are in shambles, more often than not lacking such critical supplies as rabies serum and tuberculosis drugs.

Brij Lal is but one tragic example of the failure of the health services system in Baba ka Gaon. He and two other local teenagers who are crippled by polio have lived their entire lives without any medical care whatsoever, let alone the physiotherapy, surgery, calipers, and crutches that would have given them some strength and mobility. Several other children suffer from cerebral palsy; one likely cause is brain injury resulting from a lack of skilled care for their mothers during childbirth. And because of chronic malnutrition and illness, the poor of Baba ka Gaon are inches shorter and far frailer than the village's upper-caste people.

Yet, despite such persistent adversity, there has not been a single case of polio paralysis in Baba ka Gaon for half a decade because of the massive effort to immunize every child.

These accomplishments did not occur by magic. Multiply the slums a million fold. The villages 500,000 fold. The cities and towns several thousand fold. Add broiling summer heat, periods of relentless monsoon flooding, sweeping epidemics, pervasive illiteracy, economic crises, and every type of civil emergency. Only then can one define the scope of the challenge of putting OPV drops into the mouths of India's nearly 150 million children at least four times before their fifth birthdays.

The seeds of this gargantuan undertaking were sown in November 1985, at a ceremony in the United Nations General Assembly commemorating the UN's fortieth anniversary. Joining seventy other countries, India committed to immunizing, within five years, at least 80 percent of its infants against the six major vaccine-preventable diseases in the first year of life, in concert with the goals of the UNICEF- and WHO-driven Child Survival Revolution. (Eighty percent was adopted as the proxy for "universal" coverage because 100 percent coverage against all six diseases is considered virtually unachievable. Although several countries have coverage rates above 90 percent, no country has managed to accomplish true universal coverage.) Prime Minister Rajiv Gandhi announced that this effort was to be a "living memorial" to his mother, Indira Gandhi, who had been assassinated the

previous year. Such unprecedented political will catalyzed the singular national effort and investments needed to achieve the universal immunization goal in just five years.

Across India, but with greatest effectiveness in the southern and western states, the government painstakingly resolved the innumerable problems that had previously thwarted immunization services. To build the cold chain, thousands of broken-down refrigerators were repaired or replaced. Distribution systems were improved, making it possible to deliver vaccines, needles, and syringes according to planned schedules and in the necessary quantities. Vaccine manufacturing in India was accelerated in order to produce a much greater percentage of the needed supplies. Trained managers were put in place to ensure accountability for vaccine distribution and immunization itself. Medical and family welfare workers at every level, from hospitals right to every one of the 150,000 tiny sub-centers, were trained in immunization. Techniques, plans, and strategies for all phases of the immunization effort were improved, streamlined, and refined.

A recurring reason for the failure of previous immunization services at the village level was the erratic timing of visits by local auxiliary health workers. With no fixed schedule of visits, village parents never knew when they should be at home and have their children ready for immunization. In a major strategic breakthrough, the government

INDIA, 2001. The Haffkine Bio-Pharmaceutical Compound, Mumbai. India is self-sufficient in the production of most vaccines for common childhood diseases. Polio is the exception: oral polio vaccine is imported in bulk in a concentrated form, then blended and put into individual vials at this company, which is owned by the state of Maharashtra.

introduced the concept of "fixed immunization days." Local health workers, bearing vaccines collected from primary health care centers, began to schedule visits to each village on a fixed day every month. Ultimately, this simple innovation revolutionized not only the delivery of immunization, but also a range of other preventive health services such as prenatal and child care.

Immunization coverage levels rose rapidly. But, as late as 1989, it was still unclear whether India would succeed in achieving universal immunization coverage by the target date the following year. The chances of success were imperiled by the laggard performance of many northern states, particularly Bihar and Uttar Pradesh.

An all-out effort was initiated. A massive communication campaign ran nationwide to motivate parents to seek immunization for their children. Private doctors were drawn into the effort through the Indian Medical Association; in some cities, private physicians vaccinated between 10 and 25 percent of children. Communities, even whole cities that had proved particularly difficult to reach, or which lacked health centers, were targeted for intense and focused immunization "mop-up" operations. In Kolkata, for example, coverage levels were raised from below 20 percent to 85 percent in a matter of months. The under-performing northern states received unprecedented support, including aid from UNICEF and WHO. By the end of 1990, the Indian government concluded that it had indeed succeeded in immunizing at least 80 percent of infants within their first twelve months of life.

This great strengthening of routine immunization was a critical advance in India's effort to end polio. In less than a decade, polio immunization rates had risen to close to 90 percent.

In much of northern India, however, progress had stalled altogether in the early to mid-1990s, tainted by the inefficiency of all public services. In 1995, Indian children, most of them from the northern and eastern states, accounted for nearly half the estimated 75,000 new cases of polio paralysis occurring in the world. India's prospects for defeating polio certainly did not look promising.

Fortunately, the Indian government's commitment to eradicating polio was now so powerful that it soon took decisive measures to reverse the downhill trend in immunization coverage. In late 1995, nationwide, intensive polio-immunization campaigns, known as "National Immunization Days," were initiated, and this stepped-up operation turned the tide.

Such campaigns had become the cornerstone of the worldwide eradication effort. In 2001, they were used in almost 100 countries, covering 575 million children. They are modeled on the mass campaigns that were pivotal in defeating polio in Latin America in the 1980s. By the mid-1990s, 36 countries in Africa, Asia, and the Middle East, including China, had instituted their own versions of National Immunization Days. Previously,

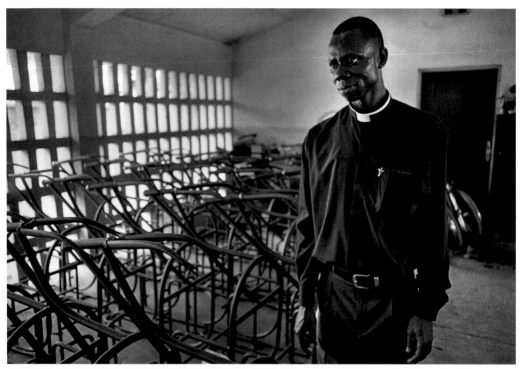

DEMOCRATIC REPUBLIC OF CONGO, 2001. In the Rehabilitation Center workshop in Kinshasa, handicapped workers assemble prostheses, wheelchairs, and bicycles for victims of polio.

routine immunization coverage in much of Africa had remained low, with political will for the eradication effort still not entirely steadfast.

In 1996, Nelson Mandela, the continent's pre-eminent leader—then president of a new, apartheid-free South Africa—led the launch of a mass immunization campaign for the entire continent, dubbed "Kick Polio Out of Africa." As elsewhere, it proved to be the decisive strategy against polio on that continent. Variations on these national days include regionally "synchronized" campaigns, covering several countries that share the same epidemiological characteristics. Synchronized campaigns have embraced up to seventeen West African countries at one time and are common practice in several other regions.

In India's first national immunization campaigns in December 1995 and January 1996, 87 million and 93 million children under the age of three were immunized against polio. Two million volunteers were mobilized to help operate half a million immunization posts across India. Of the volunteers, 100,000 were Rotary members.

In 1999, when the target group was extended to include all children under five, 127 million children were immunized in just a few days—the largest health event ever organized by a single country. The same year, India's national polio campaigns were made even more efficient by replacing the system of immunizing at set locations like clinics, with the adoption of a "house-to-house" strategy, further lowering the risk that children would be

overlooked. "Sub-National Immunization Days" were also undertaken, targeting high-transmission areas. By 2001, India was immunizing nearly 150 million children during its National Immunization Days, usually holding two such campaigns every year, and scheduling several sub-national campaigns as well.

Still, the outbreaks of new cases in 2002 dramatically exposed remaining gaps in immunization coverage. At this writing, additional resources are being mobilized, within India and by international partners, to fill these gaps—reaching those not vaccinated and convincing their families of the benefits of immunization. It is no exaggeration to say that the fate of the entire global effort hinges on the success in reaching these communities—these, and the unreached children of Nigeria, the only other country that experienced a surge of new cases (estimated at 190) in 2002.

THE HOUNDS OF WAR

In the chaos of war, diseases thrive, spreading yet more destruction and tragedy—so fiercely that they often kill and maim many more people than all the guns, landmines, bombs, and missiles used in a conflict. Polio is one of these hounds of war. In a war zone,

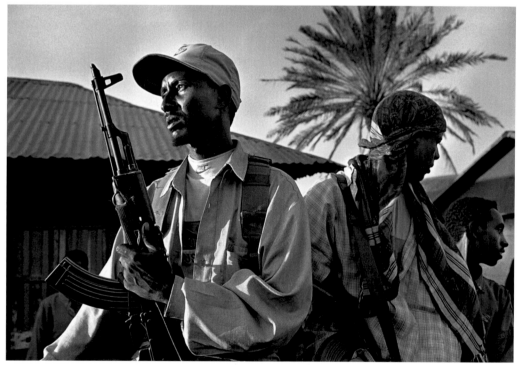

SOMALIA, 2001. Armed guards accompany immunizers during Somali National Immunization Days (NIDs) as clan warfare continued to fracture the country. UN agencies negotiate "Days of Tranquillity" with all warring factions to ensure access to every community during NIDs.

vital water supplies and sanitation systems are primary targets of destruction, giving rise to the unhygienic conditions that allow poliovirus to thrive. The disease then runs amok because great numbers of children are inadequately immunized—immunization programs are among the first victims of warfare, curtailed when hospitals, clinics, and vaccine stores are plundered and demolished, roads become unsafe, transport vehicles are destroyed and health workers are forced to flee for their lives. Consequently, polio has flared up in virtually every area of armed conflict, even in places like Iraq and Chechnya that had at one time ended transmission of this disease.

This grim reality makes the achievements of the global polio eradication effort all the more extraordinary. By the end of 2002, the war-ravaged countries of Angola, the Democratic Republic of Congo, Ethiopia, Sierra Leone, and Sudan had all completed at least one full year without a single new case of polio paralysis. Soon, the sole remaining war-afflicted *and* polio-endemic countries, Afghanistan and Somalia (with nine and three new cases, respectively), are expected to follow their lead. The conquest of polio in the midst of armed conflicts testifies to the dedication and courage of the people who have actually implemented these programs. Likewise, it proves the effectiveness of strategies, developed during the "Child Survival Revolution" years of the 1980s, for carrying out immunization campaigns in the disastrous conditions of outright warfare.

Since then, these strategies have created innumerable ceasefires to facilitate immunization and relief services for children in war-torn countries such as El Salvador, Lebanon, Sudan, and Uganda. UNICEF and WHO pressed the powerful case that children have inalienable rights that transcend politics and cannot be denied, even during war. This principle was enshrined in the 1989 Convention on the Rights of the Child. The world's most widely ratified human rights treaty, it requires warring parties to "take all feasible measures to ensure protection and care of children who are affected by armed conflict." The following year, at the World Summit for Children, world leaders resolved that, "periods of tranquillity and special relief corridors must be observed for the benefit of children, where war and violence are still taking place." Against all the odds, these "Days of Tranquillity" are almost universally respected by warring factions.

AFGHANISTAN: AMID RELENTLESS WAR

Nowhere is the achievement of humbling polio during war more remarkable than in Afghanistan. Since 1979, in one of the longest-running conflicts of the past century, this country of more than 20 million people has been ravaged by warfare of one kind or another. First, invasion by the former Soviet Union and a long battle of resistance; then bloody civil conflicts instigated by rival war-lords; then intense aerial bombing of the Taliban-held regions by a United States-led international coalition in the closing months of 2001.

The extent of the devastation I encountered on visiting Afghanistan in May 2002 was truly gut-wrenching, despite the rebuilding efforts begun in the preceding few months of relative calm. Entire neighborhoods in Kabul, the capital, consisted of only the shells of the expansive mud or brick homes that once stood there, their walls reduced to columns, roofs to patches. Everyday public necessities, such as functioning sewage systems, electrical power, and adequate drinking water simply did not exist in most areas.

Virtually every major building in Kabul—even the main hospital—was punched through with gaping holes from missiles, or pockmarked by bullets. At the central bus terminal, blackened skeletons of burnt buses were stacked sky-high. Outside the city, far into the countryside, telephone and electric wires dangled from shattered pylons. The factories and warehouses that once ran from the airport nearly to the city had all but vanished, the occasional rusting roof or machine the only proof that business once thrived in Afghanistan.

Even this staggering visible damage does not capture the devastation heaped on Afghanistan's people. In over two decades of warfare, some two million Afghans were killed, 200,000 of them by landmines alone. Approximately another million have been

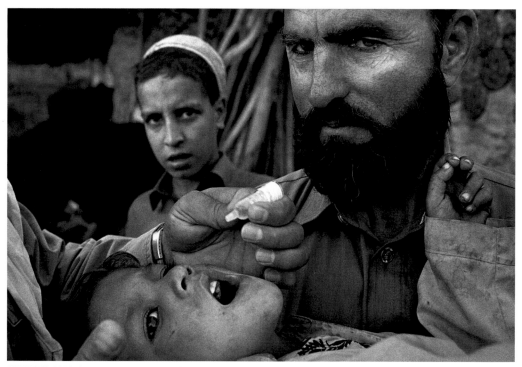

PAKISTAN, 2001. Oral polio vaccine is administered in Copar, a village in the district of Charsadda, near the border with Afghanistan.

permanently disabled. Over five million have fled their homes—four million of them going abroad. One million of Afghanistan's children have been orphaned.

Now, one in four children dies before the age of five. Life expectancy for Afghans, just 46 years, is among the world's lowest. About one of every six districts lacks even a single medical center. Tuberculosis and malaria together kill over 500,000 Afghans yearly. Proportionately, more Afghan women die in pregnancy and childbirth than in any other country in the world, with the exception of Sierra Leone, which is equally war-ravaged. It is estimated that perhaps five million Afghans suffer from psychosocial distress caused by war-related trauma, yet, in the whole country there are only eight psychiatrists to cope with this mental health crisis. Just over a tenth of Afghanistan's people have access to safe water or adequate sanitation. Fewer than a third of boys and a tenth of girls have ever had any primary education.

Afghanistan's roads, once deemed to be among the best in Asia, now terminate at the outskirts of its cities and towns. Landmines and unexploded ordnance are concealed throughout urban neighborhoods, agricultural fields, and along thoroughfares, killing or maiming 300 people every day. Pervasive landmine damage to fields and irrigation systems, and the effects of three years of drought, has made farming all but impossible. The country's economy has been decimated.

Despite all this, thanks to immunization efforts begun in the mid-1990s and sustained throughout the deadliest periods of warfare, Afghanistan is now on the verge of conquering polio. With only nine Afghan children paralyzed by polio in 2002, its complete defeat in the near term is almost a certainty, an astounding feat of human ingenuity and heroism. As recently as 1996, a survey in Kandahar Province, one of the most heavily mined areas, showed that the most frequent cause of disability among children at that time was not landmines—which actually kill children more often than they maim—but polio. How is it that Afghanistan has managed to conquer polio to the point of imminent eradication, even in the face of catastrophic warfare?

In the 1970s, Afghanistan's government improved health conditions by establishing a nationwide system of local health centers, backed by hospitals, laboratories, medical schools, and services for immunization and tuberculosis control. Unfortunately, the system was laid waste in the brutal warfare that began near the end of that very decade. By the early 1990s, fewer than 25 percent of Afghan children were fully immunized against polio; in some provinces, just one in ten was fully protected. The rates of immunization coverage against measles and other childhood killers were no better.

To stem the worsening onslaught of infectious diseases, in 1993 UNICEF and WHO launched the development of a nationwide network of health centers that would provide immunization against the six major vaccine-preventable childhood diseases. With rival groups controlling regions of the country, it fell to these two agencies to persuade each

rival faction to allow the establishment of the health centers, to provide safe passage to the carriers of vaccines and equipment, and to permit health workers to perform the immunizations without interference. Senior representatives from UNICEF and WHO made direct appeals to Afghanistan's warring groups through letters and personal meetings with their various leaders. In every case, they secured the way for immunization programs with the compelling emotional plea: "These are your children. You must protect them. Please allow them to be immunized."

Once access was assured in each area, UNICEF and WHO supported local health officials and non-governmental organizations in establishing health centers, usually conjoining them with existing hospitals or clinics. By 1997, more than 200 centers for the "Expanded Program on Immunization" had been established across Afghanistan. Each was staffed by two vaccinators, educated Afghan men and women trained to perform the inoculations and to convince parents of the need to unfailingly have their children vaccinated.

Keeping the centers functioning through the war years was extraordinarily difficult. Yet, somehow, the refrigerators that were essential to the preservation of the vaccines were kept in running condition, even under the most primitive circumstances. Where electricity sources were suddenly cut off, kerosene-powered refrigerators were quickly installed. Somehow, vaccinators maintained regular "outreach" forays—spending eight to 16 days of every month traveling by bicycle or horseback to inoculate children in remote villages. Health centers, however far-flung the location, received their supply of vaccine.

This network raised immunization levels significantly, each year saving thousands of Afghan children from death or disability. But, it soon became evident that the six-disease immunization effort carried out by these centers would not be sufficient to achieve the goal of completely ending polio transmission. In 1997, confident that the established network of centers made possible an intensified campaign, UNICEF and WHO moved to launch National Immunization Days for polio immunization.

In the face of continuing wars, the national campaigns have taken place without fail—at first twice a year, increasing to four times a year in 1999, and then to five times in 2001. In every three-day campaign, five to six million children under the age of five have been immunized with the oral polio vaccine, helped by 40,000 to 60,000 workers, half of whom—teachers, students, religious leaders and ordinary villagers, men and women alike—were volunteers. These campaigns were possible because warring groups, including those of the Northern Alliance and the Taliban, agreed to "Days of Tranquillity" so vaccinators could move unimpeded across the country.

In 2001, three national immunization campaigns had been successfully completed when the disastrous events of September 11 in the United States suddenly threatened to derail Afghanistan's polio eradication efforts. The year's fourth national campaign had

been scheduled to take place later that month. International military action against the Taliban seemed imminent and all UN relief agencies were required to evacuate their international staff from the country. But, having already negotiated a ceasefire, the national staffs of UNICEF and WHO, joined by thousands of others, went ahead with the national campaign.

Although fraught with hazards, the September campaign paled compared to the terrible conditions in which the year's final immunization rounds, in November, were carried out. The United States-led international coalition attack on the Taliban and Al Qaeda was at its height. Hundreds of thousands of people had fled from Kabul, Kandahar, and other towns to villages or to other countries. At night, massive deployments of bombers swept over Kabul and other areas in central and southern Afghanistan. Still, for three straight days, in virtual isolation from the rest of the world, the polio campaign was carried out, driven by a corps of over 33,000 volunteers and 3,000 supervisors and coordinators, all Afghans. In major cities and towns, the Afghan staff of UNICEF and WHO, numbering about 225, supported them. Despite the overwhelming odds, the campaign of November 2001 was every bit as successful as previous campaigns had been, resulting in the immunization of more than five million children.

The campaigns of 2002, with international staff and resources back in position, have continued, including children among the almost two million Afghans who returned from refuge in other countries. As with all their campaigns, these are synchronized with Pakistan, a critical aspect of both countries' eradication efforts given the continuous flow of people across their common border.

THE END OF POLIO?

Wondrously, the end of polio, its complete and final eradication worldwide, is nearly achieved. It is not clear whether the goal of a polio-free world will actually be met by 2005, but the end is imminent. To be certified polio-free, a country must have had no new cases for three years. Neighboring countries must find a way to avert cross-border contamination; indeed, all polio-free countries, certified or not, must resist outbreaks of "imported" wild poliovirus.

True, there is a genuine risk that the window of opportunity to permanently do away with polio might close forever. The 2002 surge in cases is likely just a bump in the road, but it will take funding and determination to get over it. The more disturbing issue, perhaps, is whether the new uncertainties of the post-September-11 world will undermine the international political commitment necessary to eradicate this disease.

Still, optimism is justified. Having overcome every imaginable obstacle to reduce polio to its lowest point in history, it is impossible to conceive of humanity being cheated of the ultimate victory of eradication. We—all of us, the citizens of the world—are so

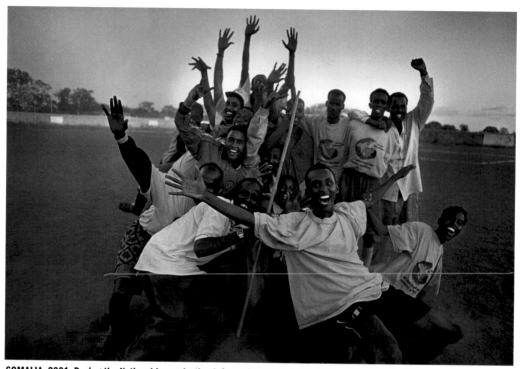

SOMALIA, 2001. During the National Immunization Information Campaign in Baidoa, the public is informed about an upcoming football game promoting immunization. Such games usually attract large crowds.

close to achieving the end of the scourge of polio that we cannot, and must not, allow our will to flag.

"The end of polio." These words are like sweet, stirring music to me. While writing this essay, I have often whispered them to myself—"the end of polio, the end of polio." To me, the words have a kind of magic because of the great promise they hold.

Illogically, I have the sense that the end of polio will somehow, miraculously, mend the tragedy that marked my birth—Pratap's paralysis. I have even allowed myself to imagine that, on the day that polio is finally eradicated, his muscles will be made whole, the agony of his childhood suffering taken away and new years given him to make up for those blighted by pain.

I realize that this is a dream. Still, the end of polio will thrill me. For it will mean that soon the wards in Kolkata's Rehabilitation Center for Children and Delhi's St. Stephen's Hospital—or hospitals anywhere in the world—will no longer be filled with terrified children with withered limbs, awaiting grueling operations, or children recovering from surgery, in unbearable agony, their ankles, knees, and hips literally pulled apart. Nor will anguished parents be forced to witness their children's suffering, powerless to

comfort them, unable to assure them that they will ever walk or run again. In the rehabilitation rooms, there will be no more children battling frustration and physical agony for months on end, as they struggle to crawl, to stand, or even to lift a tiny weight with their legs.

In time, in not a single city, anywhere in the world, will the streets be filled with beggars crippled in childhood by polio. In the villages, there will no longer be destitute young men and women condemned by polio and the paucity of medical care to a lifetime spent crawling from place to place, or lying helplessly supine, day, after day, after day.

Yes, the prospect of the end of polio fills me with great optimism. Optimism, because if polio can be eradicated simply because tens of millions of caring people around the world joined together in solidarity, then surely we can end the millions of deaths each year from other diseases for which effective vaccines are already available. Why can't our solidarity be enough to end the AIDS pandemic? To achieve nuclear disarmament? To end war? To finally end illiteracy? To finally end hunger? To finally end all poverty?

The end of polio, now within our reach, testifies that all these great accomplishments are indeed within our collective power to achieve.

My essay is dedicated with love and respect to my brother Pratap—the bravest and most admirable person I have ever known.

—Siddharth Dube

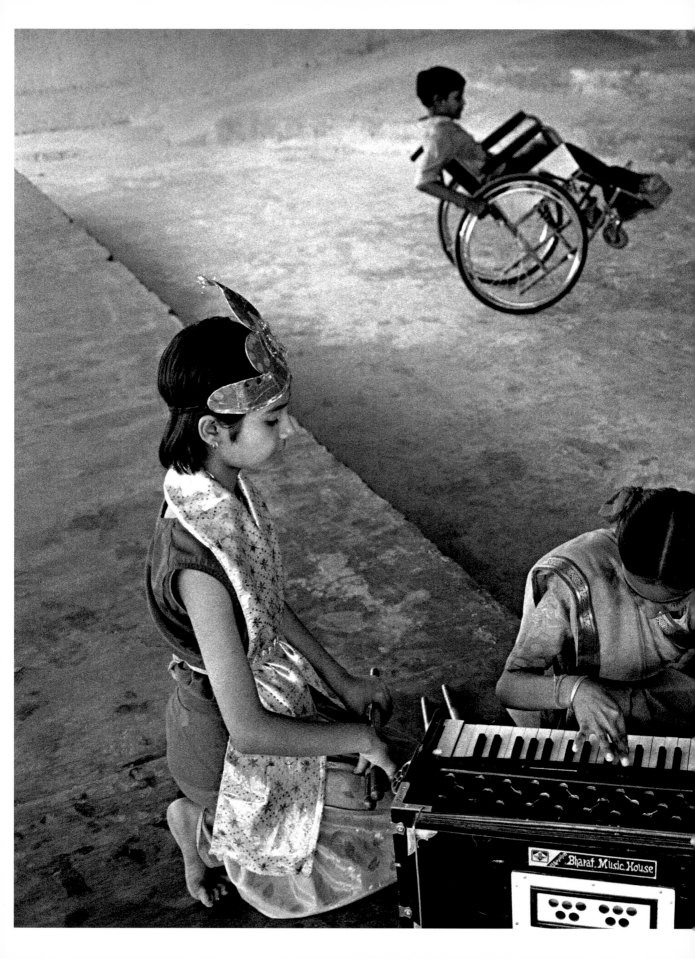

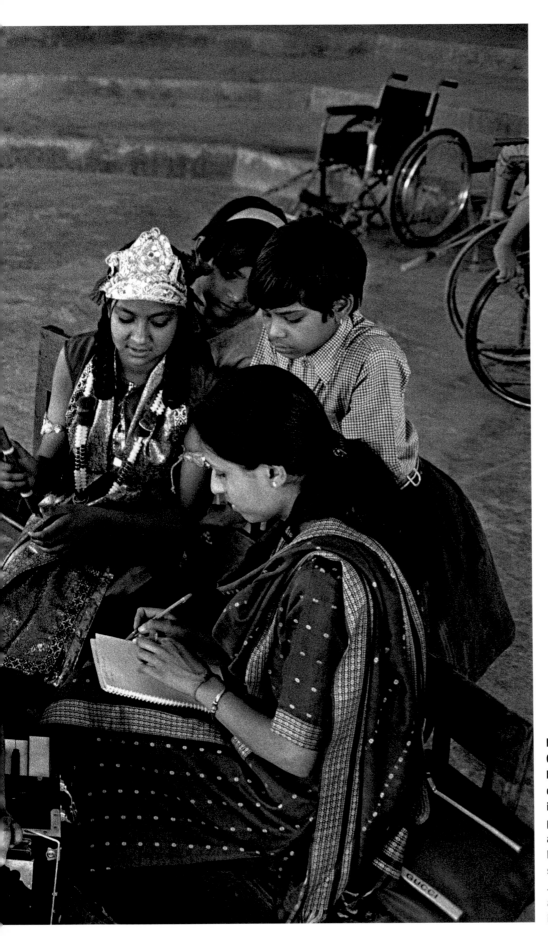

INDIA, 2001
Children disabled
by polio and other
diseases participate
in occupational and
physiotherapies,
attend school, and
learn vocational
skills at the Amar
Jyoti Rehabilitation
and Research Center
in New Delhi.

UNITED STATES, 2001
At the Centers for
Disease Control and
Prevention in Atlanta,
samples of poliovirus
are collected for
analysis. Researchers
can now pinpoint the
geographic source of
different virus strands,
so immunizers can
target those regions.
On the shelf are the
last poliovirus
specimens found in
Brazil, China, Mexico,
the Philippines,
the United States, and
other countries.

AN ARCHITECT OF THE CAMPAIGN

Interview with Dr. Ciro A. de Quadros
Washington, DC, December 3, 2002

Dr. Ciro A. de Quadros is the former Director of the Division of Vaccines and Immunization of the Pan American Health Organization (PAHO) in Washington, DC. Starting in 1985, he directed the successful effort to eradicate polio from the Western Hemisphere. Then, until his retirement in late 2002, Dr. de Quadros led PAHO's efforts to eradicate measles from the same region. He has received several international awards, including the 1993 Prince Mahidol Award of Thailand and the 2000 Albert B. Sabin Gold medal. In 1999 Brazilian-born Dr. de Quadros received the highest civil award given by the Government of Brazil, the Order of Rio Branco.

What led to the choice of polio as the disease against which to campaign for global eradication?

The whole initiative started here in the Americas. In 1983 we had a new director of PAHO, Carlyle Guerra de Macedo, who was very enthusiastic about immunization. Then James Grant, Executive Director of UNICEF, visited us and declared that the Americas should show the way to achieving universal childhood immunization against six common childhood diseases by 1990. The Director of PAHO asked me if we could do it, and I said: "I think we can, but it would be much easier if we had a disease banner." By that, I meant one disease that we targeted for total control and eradication, bringing the entire immunization program to a higher level, including the surveillance component. Polio was chosen because it was a feared disease in the Americas and because it was the most feasible, for epidemiological reasons, to eradicate. Dr. Macedo accepted the idea and we launched the program in May 1985.

Our thesis, which in the end proved correct, was that eradicating one disease would strengthen the infrastructure, including epidemiological surveillance: it would bring in more resources, new organizations and partners, and the whole immunization program would benefit from it.

In March 1988 the Task Force for Child Survival and Development, headed by William Foege, held a meeting in Talloires, France, dedicated to women's and children's health. It was attended by all the main players in the multilateral and bilateral organizations and ministers of the largest countries in the world such as China, India, and Brazil. I presented our three-year polio experience in the Americas and proposed the idea of global eradication. The director of the program in Geneva was not in agreement, but Dr. Halfdan Mahler, the World Health Organization's [WHO's] Director-General, prodded by Jim Grant, agreed and they accepted. The resulting Declaration of Talloires, had as a first priority polio eradication by the year 2000. In May, 1988, WHO presented it to the World Health Assembly and the proposal was accepted.

Can you tell me about your experience in El Salvador?

In 1984, the Pan American Health Organization initiated a plan called "Health as a Bridge for Peace" in Central America and Panama. In El Salvador, at the height of the country's civil conflict, we conducted lengthy negotiations for six to eight months. First it was necessary to negotiate a cease-fire agreement between government and guerilla forces, a process that involved PAHO, UNICEF, the Catholic Church including the Archbishop, and the Red Cross. Then one-day truces were negotiated for immunization against polio and other diseases including diphtheria, whooping cough, tetanus, and measles. We started there in 1985 with the first three rounds of national immunization days.

Extraordinary social mobilization efforts accompanied the campaigns, as health workers sought to convince the population to take their children to health posts to be vaccinated. During the immunization days around 20,000 people—health workers, volunteers, and members of guerilla forces—gave the vaccinations.

Eventually, three "Days of Tranquillity" were held every year from 1985 to 1991, until peace was achieved in the early 1990s, to vaccinate practically every child in El Salvador. The lessons learned in El Salvador and Peru have contributed to the last phases of eradication of the disease worldwide: only through implementation of "Days of Tranquillity" could the vaccination campaigns be implemented in countries such as Sri Lanka, the Democratic Republic of Congo, Afghanistan, and others.

What is the advantage of the oral polio vaccine over the injected vaccine?

Polio epidemiology is different in the industrialized countries and in the developing countries. In the industrialized countries transmission of polio is oral-oral, while in developing countries most transmission is fecal-oral. The killed vaccine, which is injectable, gives you very good "humoral" immunity but does not give you "mucosal"

immunity. This means that the injectable vaccine protects the immunized individual, but the wild virus may still be ingested and excreted. The oral vaccine, on the other hand, provides complete immunity in the intestines, diminishing the potential for the excretion of the virus in the feces and even providing "passive" immunization of others who come into contact with the excreted vaccine. Especially in unsanitary conditions, these characteristics make the oral polio vaccine the first choice to stop transmission. People who get the killed vaccine will not get polio, because it is an excellent vaccine, but it does not give immunity to the community, so you'd have to vaccinate everybody to stop transmission.

Isn't it a problem that in developing countries people's immune systems often aren't strong enough, so that people are more prone to disease?

But vaccines also work for malnourished children: the immune system responds to the vaccine whether a child is well nourished or malnourished. This was demonstrated many years ago by several investigators, particularly Dr. David Morley in Africa. It is not an issue for vaccination. But it is an issue for unvaccinated children, in terms of acquiring diseases, infections, the cycle of malnutrition and infection. Take, for instance, measles: the unvaccinated, malnourished kids who get measles in a very severe form can die.

How do you see the role of volunteers?

Their role has been tremendous, and without them polio eradication would be impossible. Another benefit of the oral vaccine is that anyone can administer these two drops—you don't need to train medical personnel. The volunteers not only give the vaccine, they help transport it and keep it cold. In Peru for instance, when we had the last cases in Lima, tons of ice were necessary to keep the vaccine cold. The health system did not have enough facilities for those immense amounts of vaccine. So, in the evening, the volunteers put the vaccine thermoses in the home refrigerators of people in the community.

Is polio surveillance—the investigation of possible outbreaks—difficult to carry out and what are the obstacles?

The answer is money. Whenever you have the resources, the laboratories work very well. They have trained people, quality control and supplies. Surveillance is a labor-intensive activity, because whenever something suspicious is reported, you have to respond. This means you need trained people, transportation and gasoline to investigate. This is especially important in countries that have already eradicated a disease: when people do not see a disease anymore, complacency sets in. This is why you have to keep a very high level of pressure in the system—quality surveillance is that pressure.

Do you believe that polio eradication worldwide is completely possible, or can it only be achieved to a certain point? What happens in the case of transmission through the oral vaccine?

The wild poliovirus is totally eradicable, in that you can stop transmission in nature and ensure it is not re-introduced. That is what we mean by the eradication of polio. The other issue is that the oral vaccine, made from weakened but live poliovirus, can very occasionally revert to virulence, and cause small outbreaks if the population is susceptible —that is, if immunization coverage is low. If the virus reverts, as it has done in the Dominican Republic and Haiti, Madagascar, the Philippines and Egypt, all you have to do is a large-scale vaccination with the same oral polio vaccine, and this will stop transmission because the vaccine virus behaves like the wild virus. This and other factors mean that immunization of all children must continue at high levels for the foreseeable future.

But the cost-benefit is still tremendous, even if you continue vaccinating forever. The benefits you reap from eradication are that you won't have epidemics anymore, you will not have children paralyzed, and those children who are healthy now will grow into productive members of society. And, they will contribute to the gross national product of those countries, instead of being beggars in the streets.

What happens in case of bioterrorism, after a disease has been eradicated?

The issue of September 11 and bioterrorism is different and people are beginning to start vaccinating again against smallpox, and exploring other potential problems. But this does not really apply to polio. Immunization is likely to continue in any case and only one in 200 cases of polio infection results in paralysis, so it is a poor candidate for use as a weapon.

What diseases are being considered for possible eradication, after polio?

The polio eradication program in the Americas was part of the immunization program in general. National Immunization Days did not include only the polio vaccine: we also vaccinated against diphtheria, pertussis and tetanus (DPT), and against measles. Our intention was not only to eradicate polio, but also to improve immunization coverage and eventually conquer other diseases. The result was that when polio was eradicated, measles was already under control in several parts of the Americas.

Once their region was certified polio-free, the Ministers of Health launched a program to eradicate measles from the Americas. For the last two or three years, 46 out of 48 countries and territories in the Americas have had no cases of measles: we had transmission only in Venezuela and Colombia. Then, in late 2002, for the first time in history,

ten weeks elapsed without any measles anywhere in the hemisphere. So, we are again showing that eradication of another disease is feasible. Whether the resources can be found now for global eradication of measles, compared to improved control of the disease, is a question for the world's health ministers.

Do you think that we are close to a vaccine against HIV/AIDS?
There is not yet one, but there will be one in the future, though I don't know when. People are working on it; there is more investment now for research. In the beginning of the epidemic, most of the investments were in drugs for therapeutic purposes or in searching for a cure because drugs give more return than vaccines. The vaccine market is only about 5 percent of the whole drug market in the world—that is why there are so few vaccine manufacturers. In the beginning of the epidemic, of all the money put into AIDS, only about 1 or 2 percent was in research for vaccine. Now that is changing, and there are many ongoing trials to develop a vaccine to protect against HIV.

Why do you think that now is the best time to eradicate polio?
Our reason is simple: it is ethically unacceptable to let children be paralyzed when you can prevent it with a vaccine that costs a few cents. Until PAHO declared the goal of eradicating polio in the Americas in 1985, it was normal that people got paralyzed. A revolution in people's consciousnesses had to be made. We changed the social norm. We have to stand up for things that are unacceptable—not only for diseases but also for other issues: why should we have poverty in the world?

Interview by Carole Naggar

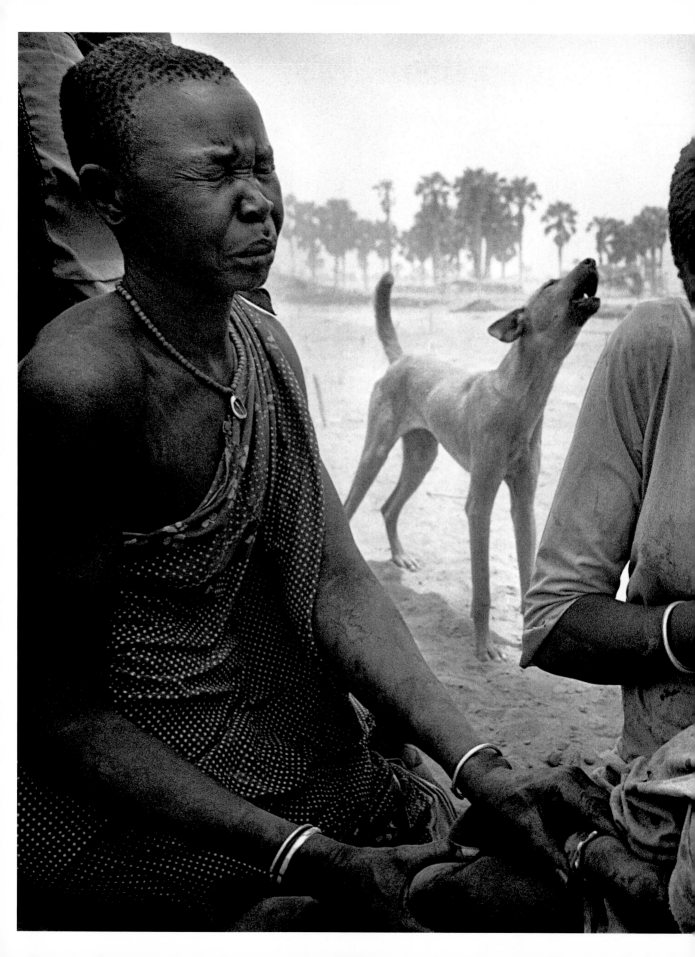

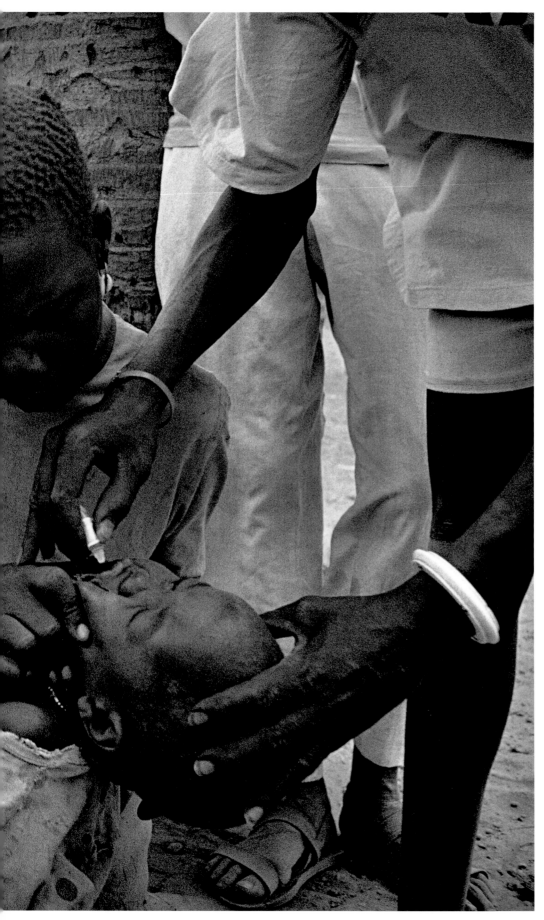

SUDAN, 2001
With only one polio case in 2001 and none in 2002, Africa's largest country has now been declared polio-free.

TIMELINE

A History of the Disease

1580–1350 BC

First evidence of polio

An Egyptian stone stele shows a young priest with a crippled, withered leg, supporting himself with a staff. He probably had polio. About 1,500 years later, Greek physician Hippocrates and his Roman disciple Galen write about acquired clubfoot in terms that suggest that what they are describing is polio.

1789 First clinical description of polio

British physician Michael Underwood provides the first clinical description of polio, referring to it as "debility of the lower extremities."

1796 First vaccine invented

British scientist Edward Jenner produces the world's first vaccine, for smallpox. He discovers that deliberate infection with the mild cowpox disease protects people from the more deadly smallpox.

1909 Polio confirmed a virus

Austrian physicians Karl Landsteiner and Erwin Popper determine that polio is a contagious disease spread by a virus and that initial infection confers immunity. A vaccine is therefore possible. A polio epidemic in Stockholm, Sweden, in 1887 is one of several to strike Europe and North America in the coming decades, the paradoxical result of improved sanitation.

1916 Outbreak in New York City

Thousands flee New York as one of the largest polio epidemics of the century strikes the city, paralyzing 27,000 people and killing 9,000.

1921 F.D.R. contracts polio

Franklin Delano Roosevelt (F.D.R.), future U.S. President, contracts polio at age 39. Six years later he establishes an innovative polio rehabilitation center in Warm Springs, Georgia. In a rare photograph that shows his leg braces, F.D.R. fishes at Warm Springs in 1925. F.D.R.'s polio paralysis was well known, but the media respected his request, for political reasons, never to show him in a wheelchair or with his leg braces.

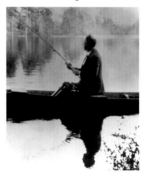

1938 March of Dimes created

As polio epidemics hit U.S. cities, President Roosevelt helps create the private National Foundation for Infantile Paralysis. The Foundation's drive to help find a vaccine becomes the highly publicized "March of Dimes" campaign, largely funded by individual contributions by Americans. These donations would also pay for a large part of the country's immunization campaigns after the introduction of polio vaccines in the mid-1950s.

1940 New treatment for polio patients

Australian Elizabeth Kenny, a Catholic nun, promotes new procedures for treating polio patients, using hot-packs and the stretching of affected limbs. Three years later, the Sister Kenny Foundation is formed in the United States, where her procedures become the standard treatment for polio patients, replacing the ineffective traditional approaches of "convalescent serum" and immobilization.

1943–1950 UN backs children's health with massive vaccinations

In 1946, a concentration camp survivor in Germany requires sensitive preparation before

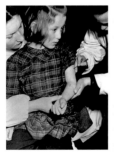

receiving a vaccination. The creation of the United Nations in 1945, UNICEF in 1946, and WHO in 1948 commits governments to addressing basic global health needs, especially of children. Following successful mass immunizations

against tuberculosis in post-war Europe and China, these organizations and the Red Cross endorse mass disease control as the top international health priority.

1952 Iron lungs in North America

Five to 10 percent of polio victims can suffer paralysis of their breathing muscles threatening death by asphyxiation. To guard against this, a breathing apparatus called the iron lung was

developed in the 1930s. Iron lungs become a common sight in North American hospital wards, like this one in Los Angeles, through the 1950s.

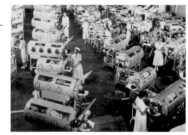

1952 Cold chain invented

UNICEF develops a "cold chain" supply system to keep vaccines cold—and potent—from manufacturer to recipient. Experience in several African and Asian countries had shown that exposing vaccine to high temperatures could make them ineffective.

1954–1957 Salk and Sabin create polio vaccines

In 1954, the first vaccine against polio, developed by U.S. scientist Dr. Jonas Salk, is ready for mass testing. Called inactivated polio vaccine (IPV) and based on a killed virus strain, its introduction creates a sensation in countries panicked by epidemics. In 1957, U.S. researcher Dr. Albert Sabin, shown here, introduces the oral polio vaccine (OPV), derived from a weakened live

virus. By the mid-1960s, OPV would largely replace Salk's vaccine because it provided complete "gut" immunity, was easier to admin-

ister and cost less to manufacture. In 1988, it would become the vaccine of choice for global eradication.

1954 U.S. polio vaccine trials succeed

Some 1.7 million U.S. children participate in field trials of Salk's IPV. The next year, children celebrate the vaccine's success as IPV is approved for general use. It would play the decisive role in blocking wild poliovirus transmissions in North America. In 1954, three U.S. scientists win the Nobel Prize in Physiology for their discovery that

polio can grow in various tissue types. This paves the way for mass manufacturing of the vaccine.

1959 Smallpox eradication launched

The World Health Assembly commits to a global campaign to eradicate smallpox.

1977 Polio in the developing world

Surveys in Africa in 1977 indicate that developing countries have polio infection rates comparable to those found in richer countries before the invention of the vaccines. However, amid widespread disease of all kinds, polio paralysis often goes unnoticed.

1980 Smallpox eradication is official

Ali Ma'ow Maalim from Merca, Somalia, contracted smallpox in October 1977, the last known case of naturally occurring smallpox infection in the world. In 1980, 21 years after the global eradication campaign began, the World Health Assembly officially certifies the world free of smallpox—the first disease ever eradicated. An estimated half-million children are disabled by polio every year.

1985 Rotary backs global polio eradication

Rotary International, a private service organization, launches PolioPlus, aimed at immunizing every child in the world against polio. Rotary's million members worldwide set a fundraising goal of $120 million to help eradicate polio, an amount they more than double in three years.

1985 First "Days of Tranquillity" and first NIDs

During a three-day cease-fire in El Salvador's civil conflict, both warring sides help vaccinate children in a campaign against six childhood diseases, including polio. Reaching 250,000 children, these "Days of Tranquillity" mark the first time that combatants stop fighting for a public health campaign. Also in Latin America, National Immunization Days against polio, called NIDs, supplement routine vaccinations, causing dramatic drops in polio transmission

1954-57 Salk and Sabin create vaccines

1954 U.S. polio vaccine trials succeed

1959 Smallpox eradication launched

1977 Polio in the developing world

1980 Smallpox eradication is official

1985 Rotary backs global eradication

1985 First "Days of Tranquillity"

rates. This prompts WHO's Pan American Health Organization to push for polio eradication in all the Americas.

1988 Global Polio Eradication Initiative launched

Member governments of the World Health Assembly launch the Global Polio Eradication Initiative, led by WHO, Rotary International, the U.S. Centers for Disease Control and Prevention, and UNICEF.

1990 Child Rights treaty and 80 percent immunization rates

In 1990, the UN Convention on the Rights of the Child, including the right to health care, becomes international law. The same year, the world achieves an average 80 percent immunization rate for all children under two against six major childhood diseases. It is a colossal achievement—ten years earlier, rates stood at 20 percent—that saves an estimated 2.5 million lives. The polio eradication effort draws on this experience.

1994 Americas certified polio-free

The Americas becomes the first of six WHO-designated regions to be certified free of wild poliovirus. In 1991, three-year-

old Peruvian Luis Fermín Tenorio was the last known polio case in the hemisphere.

1995 Last polio case in China

The world's most populous country records zero new cases of polio.

1996 Mandela launches African eradication drive

South African President Nelson Mandela, Chairman of the Committee for a Polio-Free Africa, launches an intensive campaign called "Kick Polio out of Africa" to bolster routine and mass immunizations against polio throughout the continent. In 2001, a 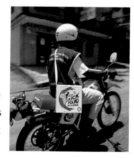 cold-storage box containing polio vaccine is transported to an immunization site in Sierra Leone.

1997–1998 Last cases in Pacific and Euro regions

The last recorded cases of infection by wild poliovirus are detected in the WHO's Western Pacific and European regions (which includes the former Soviet Union). Massive mop-up campaigns are held in southeastern Turkey and in Syria, Iraq, and Iran.

1999 India immunizes 127 million and new worldwide cases drop to 20,000

In December, India vaccinates 127 million children in just a few days—the largest public

1990 Child Rights treaty

1994 Americas certified polio-free

1995 Last polio case in China

1996 African eradication launched

1997 Last cases in Pacific and Europe

1999 India immunizes 127 million

2000 New cases drop to 2,979

2001 Fewer than 500 new cases

2002 Seven endemic countries remain

2003 Goal: Endemic countries to zero

2005 Goal: A polio-free world

health event ever undertaken. The same year, the World Health Assembly resolves to intensify the global effort and recommends adding a "door-to-door" strategy to reach every child under five. New annual cases of polio paralysis drop to 20,000.

2000 New cases drop to 2,979 and 550 million are immunized

New cases of polio paralysis drop to 2,979 worldwide. Accelerated immunizations reach a total of 550 million children, including 60 million covered in multi-country synchronized National Immunization Days in western Africa. WHO's Western Pacific region is certified free of polio. The Initiative's technical advisory group releases guidelines for laboratory containment, a condition for the certification of global eradication.

2001 Fewer than 500 new cases

New cases drop below 500, a decrease of more than 99 percent since the Global Polio Eradication Initiative was launched. Just ten polio-endemic countries remain: Afghanistan, Angola, Ethiopia, Egypt, India, Niger, Nigeria, Pakistan, Somalia, and Sudan.

2002 Only seven endemic countries remain, but isolated outbreaks put 2005 certification target date at risk

Polio endemic countries drop to seven as Sudan, Ethiopia, and Angola register no cases in 2002. But an outbreak of more than 1,500 new cases in northern India and 190 in northern Nigeria (estimated totals by January 2003) see

global trends quadrupled over 2001. Additional eradication resources focus on these countries.

2003–2004 GOAL: Polio-endemic countries drop to zero, with strengthened routine immunization services.

2005 GOAL: A polio-free world..

Title page photograph © WHO; Stele image © WHO; Virus photograph © WHO; F.D.R. photograph © Franklin D. Roosevelt Library; Concentration camp survivor photograph © UNICEF/UNRRA-1663/Norman Weaver; Iron lung photograph © WHO/March of Dimes, Birth Defects Foundation; Dr. Sabin photograph © The Hauck Center for the Albert B. Sabin archives, University of Cincinnati Medical Heritage Center; Classroom photograph © March of Dimes, Birth Defects Foundation; Ali Ma'ow Maalim photograph © WHO/J.F. Wickett; Luis Fermin Tenorio photograph © PAHO/WHO/Armando Waak; Kick Polio photograph © UNICEF/HQ01-0126/Roger Lemoyne .

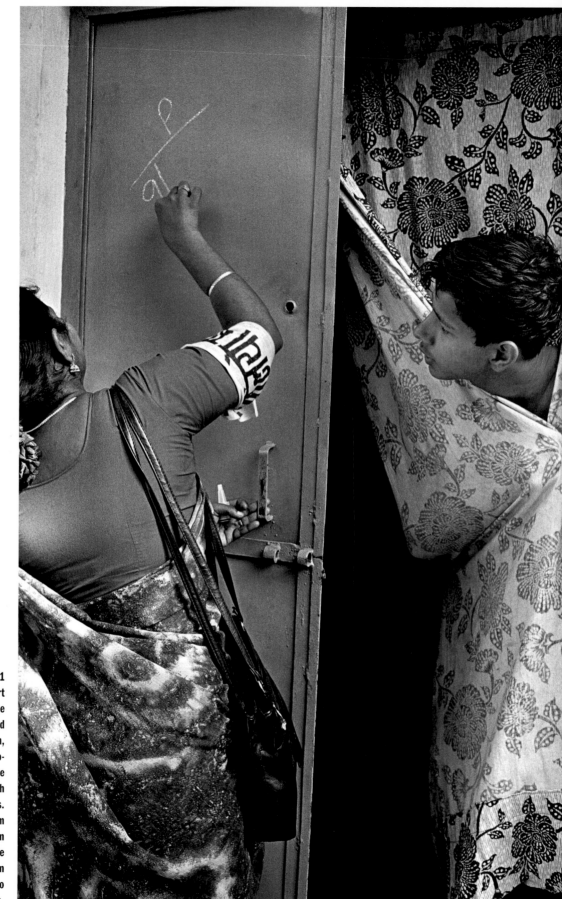

INDIA, 2001
In an all-out effort to eliminate the poliovirus in Vivekanand Nagar, Uttar Pradesh, immunizers go door-to-door to vaccinate children, marking each house afterwards. In this mostly Muslim area, vaccination teams usually include at least one woman to ensure access to all family members.

Financing the End of Polio

International funds to end polio began to flow in 1988 in the wake of the decision by the world's health ministers to concentrate on eradicating the disease globally. While the 125 countries that were then polio-endemic have shouldered a major portion of the total costs, external funding became increasingly important in the mid-1990s as the number of endemic countries fell and a progressive shift towards mass campaigns in the poorest countries accelerated.

By 2005, the target year for achieving a polio-free world, international donors will have contributed more than three billion dollars to the effort. This represents merely 0.4 percent of annual global spending on weapons. But the funds for polio eradication have, at times, arrived only sporadically and in lower amounts than necessary.

A GLOBAL PARTNERSHIP

Coordinating the worldwide campaign, including raising funds, is the work of the Global Polio Eradication Initiative, led by the World Health Organization (WHO), Rotary International, the U.S. Centers for Disease Control and Prevention (CDC), and the United Nations Children's Fund (UNICEF).

Both Rotary and the CDC are also top international funders of the Initiative, with total projected contributions through 2005 of more than $500 million and $800 million, respectively. Rotary's support for polio eradication began in 1985; its donations now constitute the largest private sector contribution ever made to a public health campaign, much of it directly from the pockets of its 1.2 million members worldwide. Throughout the campaign, WHO and UNICEF have made annual contributions in staff and other resources from their global operations.

NATIONAL AND INTERNATIONAL DONORS

Developing countries are the core contributors to their own polio immunization efforts, investing the equivalent of millions of dollars in their own currencies and even more in in-kind support and services. Latin American countries met over 80 percent of the $540 million cost of eradicating polio from their region. China has met more than 95 percent of its costs. Even countries as poor as Afghanistan and Somalia have absorbed between a quarter and half of the real costs of their polio immunization efforts.

The governments of the most industrially-advanced countries are the bedrock of international support for polio eradication. The United States, the United Kingdom, the Netherlands, Canada, Japan, and many others have given tens of millions of dollars each to the Initiative. Recently, additional large donations have also been received from the private sector, including large grants from the Bill & Melinda Gates Foundation ($75 million to date) and from the United Nations Foundation established by U.S. entrepreneur Ted Turner ($30 million to date).

International funds are vital for the purchase of vaccines and related supplies, for equipment for the surveillance systems that detect outbreaks, for the hiring of technical experts, and, in the poorest countries, for the funding of routine and supplementary immunization services. Supplies of oral polio vaccine (OPV) alone consume 40 percent of these funds, even though OPV costs only about ten cents per dose. However, the scaling up of mass campaigns in the late 1990s hugely increased demand. In 1999, the total doses needed annually rose from 700 million to two billion doses. Since then, demand has totaled about 2.3 billion doses a year, which includes routine immunizations.

This immense escalation could not have been met without the additional commitment of the four principal OPV producers—Bio Farma in Indonesia, and Aventis Pasteur, Chiron, and GlaxoSmithKline in Europe. Pharmaceutical companies have also donated millions of doses of OPV to the Initiative. The largest of these donations has been by Aventis Pasteur, totaling 120 million doses by the end of 2005. The job of securing the OPV—and ensuring that every country is supplied, in time, with the quantities they need—is handled by UNICEF, in close coordination with WHO. Today, UNICEF supplies about 40 percent of all childhood vaccines, including over two-thirds of the OPV used worldwide.

THE REMAINING FUNDING GAP

Despite generous support to date, the Initiative continues to face (as of February 2003) a funding shortfall of $275 million for the period 2003-2005. Past interruptions in sustained funding, from both international donors and developing country governments, have caused immunization goals to be missed, leaving millions of children unreached. If the polio eradication effort is to succeed, this gap must be closed.

FRANCE, 2001. Research and isolation of poliovirus at an Aventis Pasteur vaccine factory in Marcy l'Etoile. Oral polio vaccine is preferred for mass immunization campaigns because it provides complete intestinal immunity, is easy to administer, and less expensive than alternate methods.

How to Help

The global community is now on the verge of eliminating polio, a disease that once provoked fear and panic throughout the countries of the world.

The international cost for this campaign, begun in 1988, is about three billion dollars. At this printing, the Global Polio Eradication Initiative needs $275 million more in donations to be able to completely eradicate the disease. For just one dollar, a child can be protected against polio for a lifetime.

You can also help to spread the word:

• Inform friends and colleagues about polio and how close the world is to defeating this disease.
• Link your web site to http://www.endof polio.org.
• Ask media outlets in your community to report on local efforts to support global polio eradication and publicize ways people can help.
• Contact your government and ask what it is doing to help eradicate polio. Does it conduct and support routine child immunizations? Does it organize mass vaccination campaigns? Does it donate to the global campaign?
• Join other polio eradication partners, especially in your community, in information and fund-raising campaigns. For example, Rotary International has more than 1.2 million members in communities worldwide who play leading roles in volunteer and fund-raising initiatives for polio eradication. UNICEF and WHO offices around the world work with diverse local partners, including Ministries of Health and national and local school networks to implement eradication programs and to promote this and other public health campaigns.

Also, the traveling exhibition, *The End of Polio*, featuring the photographs of Sebastião Salgado, is available for rental in connection with efforts to eradicate polio. If interested, please email office@pixelpress.org.

Or, if you prefer, you can contact the lead partners of the Global Polio Eradication Initiative:

WHO
http://www.who.int *or*
http://www.polioeradication.org

ROTARY INTERNATIONAL
http://www.rotary.org

THE CENTERS FOR DISEASE CONTROL
AND PREVENTION
http://www.cdc.gov

UNICEF
http://www.unicef.org *or*
http://www.unicef.org/polio/

In the United States, you can also make a donation to the U.S. Fund for UNICEF by telephone: 1-800-FOR-KIDS (1-800-367-5437) or (212) 922-2590. If you would like your contribution to go directly to the polio eradication effort, please specify this at the time of donation.

We hope that, with your help, polio will be eradicated by the year 2005.

Selected Resources

BOOKS

General/History:

Bruno, Richard L. *The Polio Paradox: What You Need to Know*. New York: Warner Books, 2002.

Black, Maggie. *Children First: The Story of UNICEF, Past and Present*. New York: Oxford University Press, 1996.

Smith, Jane S. *Patenting the Sun: Polio and the Salk Vaccine*. New York: William Morrow & Company, 1990.

Paul, J. R. *A History of Poliomyelitis*. New Haven: Yale University Press, 1971.

Polio in the United States:

Seavey, Nina Gilden, Jane S. Smith, and Paul Wagner. *A Paralyzing Fear: The Triumph over Polio in America*. New York: TV Books, 1998.

Gould, Tony. *A Summer Plague: Polio and its Survivors*. New Haven: Yale University Press, 1995.

Rogers, Naomi. *Dirt and Disease: Polio Before F. D. R.* Piscataway, N.J.: Rutgers University Press, 1994.

Post-Polio Syndrome:

Silver, Julie K., M.D. *Post-Polio Syndrome: A Guide for Polio Survivors and Their Families*. New Haven: Yale University Press, 2001.

Halstead, Lauro S., Linda S. Halstead, and Naomi Naierman. *Managing Post-Polio: A Guide to Living Well with Post-Polio Syndrome*. Arlington, Va.: ABI Professional Publications, 1998.

Personal Stories:

Carter, Nancy Baldwin. S*napshots: Polio Survivors Remember*. Omaha: NPSA Press, 2002.

Huse, Robert C. *Getting There: Growing up with Polio in the 30's*. Bloomington, Ind.: 1st Books Library, 2002.

Gottfried, George, Edmund J. Sass, and Anthony Sorem. *Polio's Legacy: An Oral History*. Lanham, Md.: University Press of America, 2001.

Daniel, Thomas M., and Frederick C. Robbins. *Polio*. Rochester, N.Y.: University of Rochester Press, 1997.

Black, Kathryn. *In the Shadow of Polio: A Personal and Social History*. Arizona: Addison-Wesley Publishers, 1996.

Kehret, Peg, Denise Shanahan, and Albert Whitman. *Small Steps: The Year I Got Polio*. Morton Grove, Ill.: Albert Whitman & Company, 1996.

Milam, Lorenzo W. *Cripzen: A Manual for Survival*. San Diego: Mho & Mho Works, 1993.

Beisset, Arnold R. *A Graceful Passage: Notes on the Freedom to Live or Die*. New York: Doubleday, 1990.

VIDEOS

Polio, The Forgotten Disease. Dir. Jean-Marc Dauphin. France: Zorn Production International and Turner & Turner, to be released 2003.

The Last Child: The Global Race to End Polio. Dir. Scott Thigpen. Atlanta: CARE Productions, to be released 2003. http://www.lastchild.org/

A Paralyzing Fear: The Story of Polio in America. Dir. Nina Gilden Seavey. Alexandria, Va.: PBS Video, 1998. http://www.pbs.org/storyofpolio/

JOURNALS AND REPORTS

Polio Network News. International Polio Network. Saint Louis: Gazette International Networking Institute (GINI), 2002.

Post-Polio Directory. International Polio Network. Saint Louis: Gazette International Networking Institute (GINI), 2002.

Post-Polio Network (NSW) Inc. Newsletter. Kensington, Australia: Post-Polio Network. http://www.post-polionetwork.org.au

POLIO WEB SITES

Aventis Pasteur. "Polio Eradication." http://www.polio-vaccine.com/

Centers for Disease Control. "Infectious Disease Information: Polio." http://www.cdc.gov/ncidod/diseases/submenus/sub_polio.htm/

End of Polio. http://www.endofpolio.org/

Global Polio Eradication Initiative. http://www.polioeradication.org/

Rotary International. http://www.rotary.org/

UNICEF. "A World Without Polio." http://www.unicef.org/polio/

World Health Organization. "Poliomyelitis." http://www.who.int/health_topics/poliomyelitis/en/

Related Websites

Bill & Melinda Gates Foundation. http://www.gatesfoundation.org/globalhealth/InfectiousDiseases/Polio/default.htm

Polio Connection of America. http://www.geocities.com/w1066w/

The Polio Information Center Online (PICO). http://cumicro2.cpmc.columbia.edu/PICO/PICO.html

United Nations Foundation. http://www.endpolionow.net/

Immunization and Vaccines

The Albert B. Sabin Vaccine Institute. http://www.sabin.org/

Salk Institute for Biological Studies. http://www.salk.edu/

Global Alliance for Vaccines and Immunization (GAVI). http://www.vaccinealliance.org/

Post-Polio Syndrome

Gazette International Networking Institute/International Polio Network. http://www.post-polio.org/

Post-Polio Syndrome Central. http://www.skally.net/ppsc/

Editor's Note: All web addresses above are accurate as of March 2003.

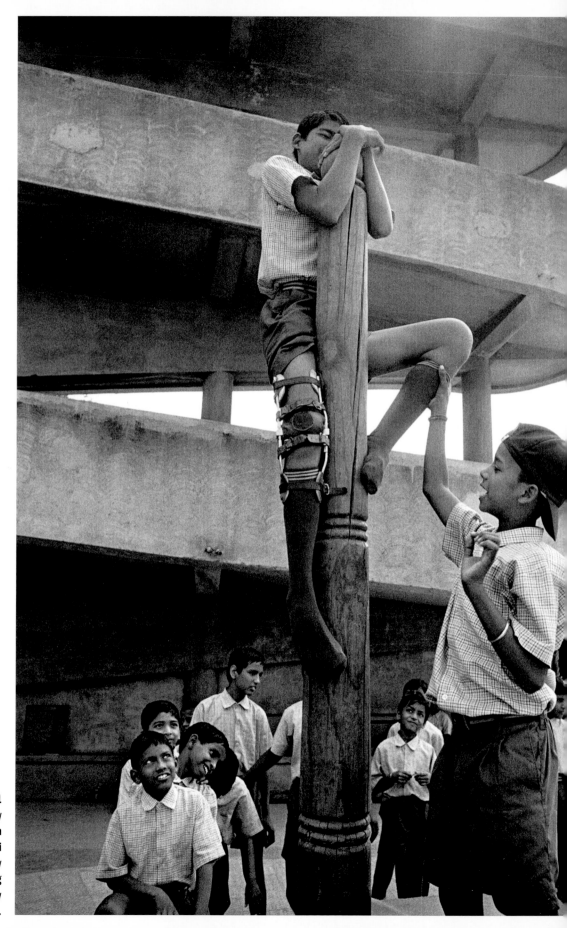

INDIA, 2001
Children at the Akshay
Pratishthan rehabilitation
institute in New Delhi
are encouraged to play
vigorously, challenging
the limits imposed by
polio paralysis.

Biographies

Born in 1944 in Aimorés, Minas Gerais, Brazil, SEBASTIÃO RIBEIRO SALGADO has received many awards for his documentary photography, especially for his large-scale projects. From 1977 to 1984 he traveled throughout Latin America, walking to remote mountain villages to produce the images for *Other Americas* (1986), an exploration of peasant cultures and cultural resistance. He then worked for 15 months with the French aid group Médecins Sans Frontières (Doctors Without Borders) in the drought-stricken Sahel region of Africa and in 1986 published *Sahel: L'Homme en Détresse* (Sahel: Man in Distress). From 1986 to 1992 he concentrated on *Workers* (1993), a documentary about the end of large-scale manual labor, for which he took photographs in 26 countries. After *Terra: Struggle of the Landless* (1997), a project on those fighting to reclaim their land in Brazil, Salgado published a pair of books, *Migrations* and *The Children* (2000), on the plight of displaced persons, refugees, and migrants in 41 countries.

In 1994 he co-founded the press agency Amazonas Images with Lélia Wanick Salgado, his wife and collaborator. Mr. Salgado was appointed a UNICEF Special Representative in 2001.

MARK DENNIS works for the United Nations in the Middle East. Previously, he was a writer and editor for UNICEF and a journalist in the Middle East and Balkans.

SIDDHARTH DUBE is a specialist in health and poverty policy. He is the author of two acclaimed non-fiction books on India: *Words Like Freedom: Memoirs of an Impoverished Indian Family*, and *Sex, Lies and AIDS*. Dube has worked for UNICEF and the World Bank, consulted for WHO, UNAIDS, and other international organizations, and has written for the *Financial Times, Washington Post*, and other leading publications.

CHRISTINE McNAB has spent several years working at the World Health Organization for the Global Polio Eradication Initiative as a communications officer. She has covered polio eradication activities in several countries, including Somalia, the Democratic Republic of Congo, and Nigeria.

CAROLE NAGGAR, a writer and painter, is the author of several books including *Mexico Through Foreign Eyes, Eikoh Hosoe: Luna Rossa*, and a biography of George Rodger.

KATJA SCHEMIONEK is a medical epidemiologist who lives in Germany. She has worked in Ecuador, Brazil, Colombia, and also in Guinea, where she set up an epidemiological surveillance system. After working as a Polio Stopper, then as a consultant in Afghanistan, she has been a coordinator for EHA (Emergency Humanitarian Action) in Kabul since 2002.

CHRIS ZIMMERMAN is a medical epidemiologist who makes his home in Boston. After several years as a primary care physician and teacher, he entered the field of public health with training at the Centers for Disease Control and Prevention and later at the Harvard School of Public Health. He currently works as a consultant for the World Health Organization on polio eradication in Nigeria, the last major reservoir of polio in Africa.

Acknowledgments

Sebastião Salgado would like to thank:

Christine McNab, WHO; Ellen Tolmie, UNICEF; Olivier Binst; Sophie Sébirot-Nossof; Richard Franco; Dr. Elias Durry, HOA Polio Coordinator; Dr. Matthew Varghese, St. Stephen's Hospital, New Delhi, India; Robert Sebbag, Aventis Pasteur; and Guy Ouakil, Aventis Pasteur.

Siddharth Dube would like to thank Pat Lone for her great kindness in allowing him the time to research and write this essay. He is also indebted to Marjorie Newman-Williams; to Yves Bergevin, Mohammed Jalloh, Stephen Jarrett, Agostino Paganini, and Ellen Tolmie for their very useful comments; and to Chulho Hyun, Tony Naleo, and Peter Salama in the Afghanistan office for their unstinting guidance. He also warmly thanks Jon Liden and Christine McNab of WHO and, for their fine editing, Barbara Ryan and Phyllis Thompson Reid.

He gratefully acknowledges as sources Maggie Black's *Children First: The Story of UNICEF, Past and Present*, and the many good reports by WHO and UNICEF.

The editors would like to acknowledge the following:

Of all the many specialists in the field of polio eradication, there are two who stood out for their generosity with ideas and their pragmatism during the arduous process of creating this book:

Ellen Tolmie, Photography Editor, UNICEF, guided us both with her vision and her practical knowledge through the complexities of the polio eradication campaign, as well as helping in the editing of the text.

Christine McNab, Communications Officer, WHO, was our sympathetic sounding board and expert on all things polio.

We would also like to thank the following professionals at WHO, UNICEF and the United Nations Headquarters:

Dr. Heidi Larson, Senior Communications Advisor, UNICEF, for GAVI (the Global Alliance for Vaccines and Immunization), whose early recognition of the potential of this project was essential to its realization.

WHO: Dr. Brent Burkholder, Ms. Louise Baker, Dr. Matthieu Kamwa, Dr. Elias Durry and Dr. Tony Mounts and their respective polio eradication teams, and Gaynor Norfolk.

UNICEF: Lisa Adelson, Joanne Bailey, Liza Barrie, Sara Cameron, Mohammed Jalloh, Neville Josie, Elizabeth Kramer, David Pitt, Marjorie Newman-Williams, and Denise Searle.

UN: Shashi Tharoor, Under-Secretary-General for Communications and Public Information, Stephen Lewis, Special Envoy of the United Nations Secretary-General for HIV/AIDS in Africa, Edward Mortimer, Annika Savill, and Richard Amdur.

We are profoundly indebted to those who helped in the making of this book: the writers, who graciously contributed their considerable expertise under tight deadlines; Victor Mingovits, who provided early design support; Michael Sand, Executive Editor of Bulfinch, who believed in this book from its very inception and patiently saw it through to publication; and Lélia Wanick Salgado, Françoise Piffard, Marcia Mariano, and Dominique Granier of Amazonas Images, who were wise and expert in their collaboration. And we are most especially grateful to Sebastião Salgado, whose photographs continue to inspire so many people around the world.

The generous support of the Global Polio Eradication Initiative and GAVI, the Global Alliance for Vaccines and Immunization, made this book possible. UNICEF and WHO would like to acknowledge Aventis Pasteur for proposing Sebastião Salgado's name for involvement in the project.

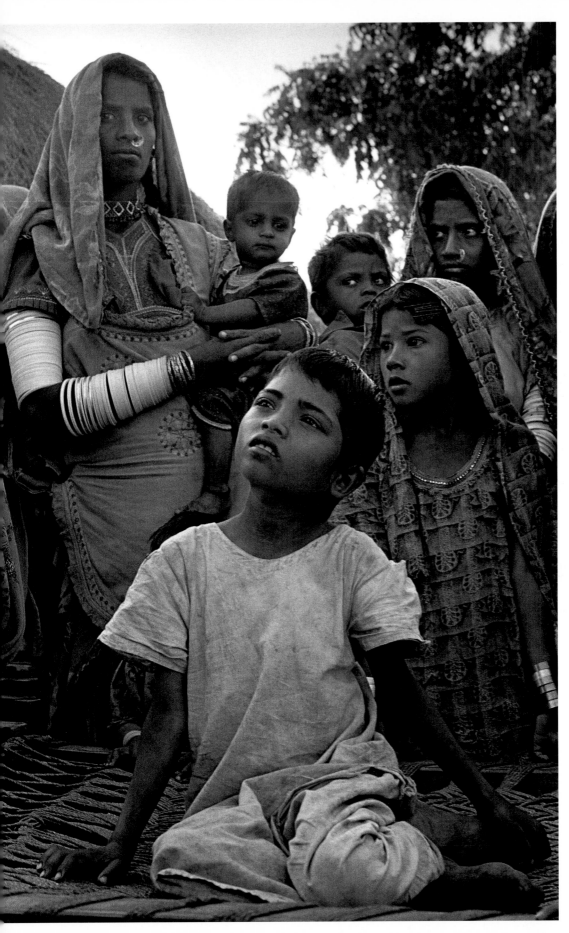

PAKISTAN, 2001
Polio immunization
campaign in the village
of Nihal-Jo Whandhio,
in the desert of Thar on
the frontier between
Pakistan and Rajasthan
State in India.

Book design and concept by PixelPress
PixelPress, LLC
134 West 26th Street, Suite 740
New York, NY 10001
www.pixelpress.org

Editor and Creative Director: Fred Ritchin
Managing Editor: Ambreen Qureshi
Designer: Wendy Byrne
Design Concept: Aviva Michaelov
Cover Design: Zohar Nir-Amitin
Editorial Consultant: Carole Naggar
Copy Editor: Phyllis Thompson Reid
Outreach Coordinator: Matisse Bustos
Editorial Assistants: Alison Beckett, Shalu Rozario

First Edition
Hardcover ISBN 0-8212-2850-1
Paperback ISBN 0-8212-2862-5
Library of Congress Control Number 2003104536
Bulfinch Press is a division of AOL Time Warner Book Group.

Printed in Italy